Libby Heaney
QUANTUM SOUP
QUANTENSUPPE

With texts by
Mit Texten von
Amira Gad
Julia Greenway
Sabine Himmelsbach
Ariane Koek
Paul Luckraft

HATJE
CANTZ

Table of contents 4
Inhaltsverzeichnis

Texts
Texte

Works
Werke

Foreword

From March 23 to May 26, 2024, the exhibition *Libby Heaney: Quantum Soup* was shown at the HEK (House of Electronic Arts) in Basel. It was dedicated to the current cycle of works by British artist and quantum physicist Libby Heaney, who explores the effects of technologies such as quantum computing and machine learning on society in her works and questions them both critically and playfully. Her oeuvre includes immersive video installations, game environments, virtual reality, sculptures, performances, and watercolour painting in equal parts. HEK presented Heaney's first solo exhibition in Switzerland with several new works. The exhibition focused on works that successfully use the quantum computer as an artistic medium for the development of an independent artistic language that makes the multi-layered reality of the quantum world tangible for the audience.

This exhibition could not have been realized without the generous support of the Kulturstiftung Basel H. Geiger. I would like to thank Raphael Suter, the foundation's director, for this. The foundation not only supported the exhibition financially, but also organised the discussion event 'The End of Aging: Dialogues at the Intersection of Quantum Science and Philosophy', at which Heaney discussed the understanding of time in quantum science with the philosopher Susanne Burri. The event took place as part of the exhibition *The End of Aging* designed by Michael Schindhelm and the exhibition *Libby Heaney: Quantum Soup* May 25, 2024, at the Kulturstiftung Basel H. Geiger.

Many thanks for their continued generous support go to the Claire Sturzenegger-Jeanfavre Foundation, whose contribution helped realise this ambitious project.

I would also like to thank the HEK's subsidisers, without whom our program would not be possible: Christoph Merian Foundation, Canton Basel-Landschaft, Canton Basel-Stadt and the Federal Office of Culture. My heartfelt thanks also go to the entire HEK team, whose members all contributed to the success of the project with great personal commitment.

We are also grateful for the collaboration with the NCCR SPIN for giving a broad audience insight into the complex world of quantum computing as part of our 'TechBrunch' educational program on May 26, 2024. My heartfelt thanks go to Professor Dominik Zumbühl and his team – Maria Longobardi, Marie Le Dantec, and Pierre Fromholz – for organizing this event with some of the research team's projects and the detailed explanations on the subject of quantum physics. We would also like to thank James Wootton from IBM Research Zurich for bringing his expert knowledge to the workshop.

Special thanks go to the artist Libby Heaney. The collaboration with her was inspiring and extremely enriching. I greatly appreciated the conversations and discussions with her; they have awakened and shaped my interest and understanding of quantum computing. I was also impressed by her openness and her ability to make the complex topics of quantum physics understandable for laypeople. I would like to thank Libby for her great commitment and the passion with which she worked on this exhibition – the result is a total work of art that allows us to immerse ourselves in her artistic cosmos. In her works, she invites us to perceive our macroscopic world as fluid, queer, and non-binary via the microscopic quantum world and to learn to look at our material world in a new way beyond binaries and polarization and thus perhaps develop a better understanding of our environment. What could be more important in our time?

Sabine Himmelsbach,
Director HEK

Vom 23. März bis zum 26. Mai 2024 wurde am HEK (Haus der Elektronischen Künste) in Basel die Ausstellung Libby Heaney: Quantensuppe gezeigt. Sie war dem aktuellen Werkzyklus der britischen Künstlerin und promovierten Quantenphysikerin Libby Heaney gewidmet, die sich in ihren Arbeiten mit den Auswirkungen von Technologien wie Quantencomputing und maschinellem Lernen auf die Gesellschaft auseinandersetzt und diese kritisch wie spielerisch hinterfragt. Ihr Œuvre umfasst immersive Videoinstallationen, Game-Environments, Virtual Reality, Skulpturen, Performances und Aquarellmalerei gleichermaßen. Das HEK präsentierte die erste Einzelausstellung Heaneys in der Schweiz mit mehreren neuen Werken. Die Ausstellung fokussierte auf Arbeiten, die den Quantencomputer erfolgreich als künstlerisches Medium für die Entwicklung einer eigenständigen künstlerischen Sprache zum Einsatz bringen, und die die vielschichtige Realität der Quantenwelt für das Publikum sinnlich erfahrbar machen.

Die Ausstellung hätte nicht realisiert werden können ohne die großzügige Unterstützung der Kulturstiftung Basel H. Geiger. Dafür möchte ich mich herzlich bei Raphael Suter, dem Direktor der Stiftung, bedanken. Die Stiftung unterstützte die Ausstellung nicht nur finanziell, sondern ermöglichte in Kooperation mit dem HEK auch die Diskussionsveranstaltung »The End of Aging: Dialogues at the Intersection of Quantum Science and Philosophy«, bei der Heaney sich mit der Philosophin Susanne Burri über das Verständnis von Zeit in der Quantenwissenschaft unterhielt. Das Gespräch fand im Rahmen der von Michael Schindhelm gestalteten Ausstellung The End of Aging und der Ausstellung Libby Heaney: Quantensuppe am 25. Mai 2024 in der Kulturstiftung Basel H. Geiger statt.

Ein großer Dank für die weitere großzügige Unterstützung geht an die Claire Sturzenegger-Jeanfavre Stiftung, deren Beitrag dieses ambitionierte Projekt mit ermöglichte.

Danken möchte ich auch den Subventionsgebern des HEK, ohne die unser Programm nicht möglich wäre: der Christoph Merian Stiftung, dem Kanton Basel-Landschaft, dem Kanton Basel-Stadt und dem Bundesamt für Kultur. Mein herzlicher Dank gilt auch dem gesamten Team des HEK, die alle mit großem persönlichem Einsatz zum Erfolg des Projekts beigetragen haben.

Dankbar sind wir auch für die Zusammenarbeit mit dem NCCR SPIN, die im Rahmen unseres »TechBrunch«-Vermittlungsangebots am 26. Mai 2024 einem breiten Publikum Einblick in die komplexe Welt des Quantencomputing ermöglichte. Für die Gestaltung dieser Veranstaltung mit einigen Projekten des Forschungsteams und ausführlichen Erklärungen zum Thema Quantenphysik geht mein herzlicher Dank an Professor Dominik Zumbühl und sein Team Maria Longobardi, Marie Le Dantec und Pierre Fromholz. Zusätzlich möchten wir James Wootton von IBM Research Zürich dafür danken, dass er sein Expertenwissen in den Workshop einbrachte.

Ein besonderer Dank gilt der Künstlerin Libby Heaney. Die Zusammenarbeit mit ihr war inspirierend und extrem bereichernd. Die Gespräche und Diskussionen mit ihr habe ich sehr geschätzt und sie haben mein Interesse wie auch Verständnis an Quantencomputing geweckt und geprägt. Beeindruckt hat mich auch ihre Offenheit und ihre Fähigkeit, die komplexen Themen der Quantenphysik für Laien verständlich zu machen. Ich danke Libby herzlich für ihr großes Engagement und die Leidenschaft, mit der sie an dieser Ausstellung gearbeitet hat – entstanden ist daraus ein Gesamtkunstwerk, das uns in ihren künstlerischen Kosmos eintauchen lässt. In ihren Werken lädt sie uns ein, über die mikroskopische Quantenwelt unsere makroskopische Welt als fluid, queer und nicht-binär wahrzunehmen und unsere materielle Welt jenseits von Binaritäten und Polarisierung neu betrachten zu lernen und damit vielleicht ein besseres Verständnis unserer Umwelt zu entwickeln. Was könnte wichtiger sein in unserer Zeit?

Sabine Himmelsbach,
Direktorin HEK

Sabine Himmelsbach LIBBY HEANEY: QUANTUM SOUP

When investigating what any technology can and can't do through art, I often turn to concepts from quantum physics as a way of understanding the pluralities and entanglements between technology, the world and ourselves. There are connections between facets of reality that we could never have dreamt of. I'm sure they will shift how people see and understand the world and our place in it.

Libby Heaney

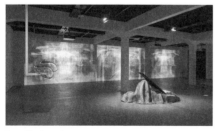

Installation shot

*B*ritish artist and PhD quantum physicist Libby Heaney's exhibition *Quantum Soup* at HEK (House of Electronic Arts) presents artworks created with a quantum computer and explores the technology's functionality and significance for society and art. At first glance, the title 'quantum soup' seems purely ironic. The term obviously doesn't refer to anything concrete, but might rather describe a layperson's vague sense of familiarity with quantum computers or quantum computing without their actually knowing much about the complex technology in which companies are investing so much money these days. While this reading is obviously intentional, the title also reflects the fundamental idea of perceiving the world in a new way, through the lens of quantum physics. This lens holds a deep fascination for Heaney and finds expression in her work in ever new ways and various formats, from immer-

1
Karen Barad in her
lecture "On Touching:
The Alterity Within,"
Gerrit Rietveld
Academie at Stedelijk
Museum Amsterdam,
March 21–24, 2018,
https://www.youtube.
com/watch?v=
u7LvXswjEBY.
Accessed March 26,
2024.

2
Ariane Koek,
_Entangle: Physics
and the Artistic
Imagination_ (Berlin:
Hatje Cantz, 2019), 17.

3
Paul Thomas,
_Quantum Art and
Uncertainty_
(Bristol: Intellect
Books, 2018).

sive installations and game engines to watercolours, sculptural glass objects and virtual reality. In her eight years as a quantum physicist, before becoming an artist, she spent her time researching the concept of quantum entanglement, i.e. how objects can affect each other even when separated across great distances, and investigating how quantum entanglement can be used in quantum information processing. Her artistic practice then developed out of the desire to bring the microscopic phenomena of a plural quantum world to light in order to rethink our seemingly fixed and limited macroscopic reality. In this sense, 'quantum soup' also can be understood as the primordial soup, the matter from which everything arises. The physicist and philosopher Karen Barad brings up the concept of a 'soup of indeterminacy'[1] in relation to understanding quantum worlds, because within quantum physics, reality is only brought into being through measurement, which however causes all other possibilities that quantum reality simultaneously holds to be destroyed or extinguished. In this primordial soup of quantum reality or quantum multiverse, everything is fluid, non-binary, and variable. It is precisely these attributes that interest Heaney, who translates their qualities into her artistic practice and into the development of an independent artistic vocabulary.

The author Ariane Koek, who in her contribution to this publication looks at the history and significance of quantum physics in art, speaks of the 'age of new phenomenologies'[2] represented by quantum theory. Similarly, the artist and theorist Paul Thomas's book _Quantum Art and Uncertainty_ explains how quantum theory will change our understanding of reality and relationship to our environment, fellow humans, and animals.[3] Heaney is considered a pioneer in her artistic work with functional quantum computers, which don't apply the binary logic of 0 and 1 but instead operate with quantum bits (or qubits) that can simultaneously process different states and possibilities. The promise quantum computers hold seems almost magical considering their exponential computing capacity as well as their potential for redistributing resources more efficiently or solving complex ecological problems. At the same time, their potential holds the risk of further propelling surveillance capitalism and ultimately annihilating data security. Heaney's keen awareness of this ambivalence is precisely why she decided to commit herself to employing the technology

from an artistic perspective and enable a broad social debate, while exploring the magic of quantum physics for a new fluid, queer, non-binary understanding of our reality.

'*A*re you ready?' she asks us as we enter the exhibition, in her works *QX Extended Advertisement* and *QX Product Launch Video* (both 2022). Are we ready for a quantum world? And to whom do we entrust the shaping of this world? These two videos address the powerful technology's ambivalence of carrying incredible potential as well as inherent danger. To this end, Heaney created the fictitious quantum computer company 'QX' (Quantum eXperience). Like existing companies in the ongoing race for the technological revolution in the field of quantum computing, QX's screens boast expertise with slogans that decry the new technology's promise of salvation, such as: 'Reach Your Full Potential' and 'We Are Accelerating The Future Of Quantum Together'.[4] Fade-ins of Heaney's work *Ent-*, which can be seen immediately afterwards, are embedded in animations of quantum computers with their impressive golden cases, ironically parodying a typical commercial aesthetic and the marketing strategies of big tech companies. The fiction of perpetual technological progress is soon marred with the appearance of little image interferences and glitches, slime beginning to cover the quantum computers' casings and the voiceover sounding increasingly slow and buggy. The critical and ironic view of the subject's complexity sets the tone of the exhibition. In both works, Heaney intertwines fact and fiction, inviting the viewer to reflect on the future of quantum computing and its socio-political significance. At the same time, the artist provides a visual illustration of the principles of quantum reality, which departs from the binary and opens into fluidity and plurality with all its indeterminacies and shifting categories.

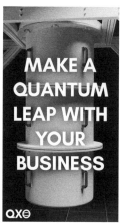

QX Extended Advertisement, 2022

*T*he 360-degree immersive projection *Ent-* (2022) transports viewers into the sense of being inside a quantum world. Inspired by the medieval imagery and bestiaries of the central panel of Hieronymus Bosch's triptych *The Garden of Earthly Delights* (ca. 1490–1510), Heaney's world is populated with scenes and creatures rendered from scans of the artist's own watercolour paintings using quantum computing. After

5
The principle of superposition refers to the ability of quantum particles to simultaneously exist in various states, until they are measured.

being scanned, the images were processed through a quantum code written by the artist to create visual effects and abstract three-dimensional coloured structures. Due to quantum entanglement's non-local signatures, these structures disintegrate into individual particles, flow through the space, or reassemble to new constellations. Heaney's choice of watercolour as a medium is intentional; the manner in which colour and water expand and retract as they mix ideally reflects the ambivalence and fluidity of quantum particles. Everything in this immersive visual world is in constant flux – viewers find themselves zoomed inside an object, where

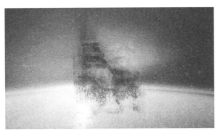

Ent-, 2022

whole new worlds appear, or plunged into underwater landscapes, with objects constantly passing through states of fragmentation and deconstruction. The soundscape whispers word pairs in English and German that variously augment the title *Ent-*, among them 'entanglements', 'entdecken', or 'enter'. They call up principles from the microscopic quantum world while reflecting the openness suggested in the title. *Ent-* leaves it up to viewers to decide what 'ent-' might become. Just like the language, the images become plural, layered and superimposed; they begin to pulsate and echo simultaneous states (superposition[5]) of the quantum world into which the artist lets us step.

*E**nt-* also dives into the ambivalence and belief systems surrounding quantum computers. Just as Hieronymus Bosch's famous triptych opens into a parallel depiction of heaven and hell, where life's joys are closely knit with threats of danger, the future development of the technology of quantum computing is still brimming with potential and dangers. Accordingly, *Ent-* meanders poetically between emergence and dissolution, focusing on the fluidity and plurality of all matter. In her contribution to this publication, the author Amira Gad speaks of the concept of un-shaping, i.e. a world where there are no boundaries, a world that cannot be shaped. While *Ent-* offers an immersive experience, Heaney's *Ent- (many paths version)* (2022) enables viewers to independently explore their world using a game controller.

Q *is for Climate (?)* (2023) proposes a new quantum-based understanding of our environment, it's title already pon-

6
Libby Heaney in one of her Instagram posts. https://www.instagram.com/Libby_Heaney_/?hl=en. Accessed March 26, 2024.

7
https://www.nature.com/articles/nphys766. Accessed March 26, 2024.

dering whether the quantum computer could show us a way out of the climate crisis. Simulated landscape images mingle with animations of quantum computer casings and the tentacles of an octopus like creature. Water sounds draw us into our world's primordial state; the images are overlaid with oily black slime that pours over the landscape, stirred by a pulsating sound. 'Quantum particles are shape-shifting. Their properties literally come into being through entanglements with the rest of the environment', Heaney writes. [6] The work indicates this with a multitude of superimpositions and perspectives that refer to the non-linear time of quantum physics, where particles can move in all directions simultaneously. Instead of using the potential of quantum computers to further the extractive capitalism of our time, the principle of quantum entanglement could serve as an example of how a non-binary, queer, and plural quantum-based understanding of the world, one in which human and non-human actors are equal, enables us to coexist more beneficially with our environment.

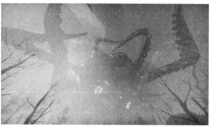

Q is for Climate (?), 2023

The two glass objects *Supraphrodite (i)* and *Supraphrodite (ii)* (both 2024) were newly created for the exhibition. Heaney explains how the materiality of glass is a kind of mirror image (in terms of temperature) of quantum particles, while their properties are comparable: Glass liquefies in extreme heat, whereas quantum particles (atoms and molecules, which behave differently from the so-called solids we see in the macroscopic world) liquefy and become wavy in extreme cold (which is why quantum computers operate at temperatures around -270 degrees Celsius). Glass slows down light waves through refraction, whereas quantum particles can freeze and unfreeze the movement of light. [7] Working with molten glass is a random, unpredictable, and organic process. Both glass artworks consist of two transparent glass cells joined together, liquid forms solidified. In their translucency, the objects produce numerous refractions and reflections of the light from the video works in the exhibition space, constantly offering viewers new perspectives and angles. Their titles refer to Aphrodite, the goddess of beauty and

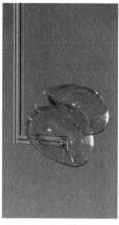

Supraphrodite (i), 2024, installation shot

8
Libby Heaney in one of her Instagram posts. https://www.instagram.com/Libby_Heaney_/?hl=en. Accessed March 26, 2024.

love, who, according to myth, was born from white foam. The name Supra is derived from Latin and means 'above' or 'to go beyond', another allusion to the theme of dissolving boundaries and entanglements in a quantum reality.

*I*n the three-channel video installation *slimeQrawl* (2023), Heaney uses slime as a metaphor for quantum particles. The fluid and shape-shifting qualities of this material wonderfully visualize the behaviour of quantum particles, which Paul Luckraft and Julia Greenway describe in their contribution to this publication. *slimeQrawl* shows close-ups of slime being kneaded with hands and placed in Heaney's mouth. In renderings, the slime oozes out from the joints of models of contemporary quantum computers, pouring over the entire image. Heaney employed IBM's five-qubit quantum computer to create the video, using a code she developed to reveal the wavelike signature of different types of quantum entanglement. The resulting parallel superimposed images reflect the principles of quantum states. Slime becomes a 'collective

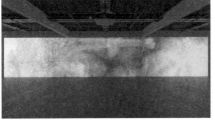

slimeQrawl, 2023, installation shot

intelligence', a 'collective body' beyond fixed boundaries. [8] The embodiment and physicality, which the slime vividly illustrates, draws the images from the fascinating machinery of the quantum computer into a direct connection with the images of human bodies, achieving a sense of unison.

Please Don't Cry, 2023

*E*mbodied experience and quantum reality are also the theme of the three video works *What's Love Got To Do With It*, *Never Too Much*, and *Please Don't Cry* (all 2023), where Heaney reflects on the strong personal feelings and memories of her own subjective experiences, exploring how trauma and memory have a quantum-like character. In *What's Love Got To Do With It*, slime is kneaded and squeezed through hands with manicured fingernails in an often deliberately blurred overlay of images. Similar to the manipulation of a stress ball, the process seems to release aggression and at the same time the work gives the impression that something else (a monster?) is emerging. In *Never Too Much*, mucus emerges from a mouth, sucked in and regurgitated in continuous flux. Despite the title's negation, the experience seems to involve

In a conversation with the author, Libby Heaney explains how the work is also a reaction to or processing of her childhood. Accordingly the work can also be read as a response to 18 years of paternalism, particularly since the video's duration is exactly 18 minutes – one minute for every year of growing up. In this sense *Never Too Much* serves as an act of liberation and self-empowerment.

10
Please Don't Cry has a duration of 34 minutes. Heaney's sister wars 34 years old when she died.

one too many; the gesture of ingesting and expelling the mucus also appears as a moment of retching and expressing overwhelm. [9] In *Please Don't Cry*, we see a close-up of a made-up eye. Tears appear, and we realize that the person, who is again Heaney herself, is crying. [10] The work was created in the context of the artist's mourning and remembering her deceased sister, therefore establishing a relationship with *Heartbreak and Magic*, another work that revolves around this painful loss. All three video works are impressively intimate, further enhanced by the physical relationship viewers are drawn into through their setting where each of the screens is embedded in an organic or pedestal-like structure that echoes the tonality and colour of the work.

*T*he exhibition concludes with *Heartbreak and Magic* (2024), a virtual reality work accompanied by two large-format watercolours titled *'all my colours for you'* (2024) and *God Ray's Tick Tick* (2023). Heaney often enters her artistic process and finds ideas for her works through watercolour painting, the medium's fluid qualities ideally reflecting the plurality of quantum reality. The two paintings include tentative sketches, comments, and textual annotations that

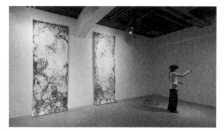
Installation shot

illustrate the research and creation process of Heaney's artistic practice. The genesis of her works takes shape in a various experimental process that also involve movement practice and breathing exercises in addition to writing, drawing, and painting, and then quantum computer coding with which analogue data is processed and transformed.

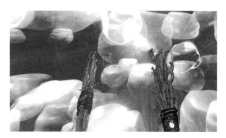
Heartbreak and Magic, 2024

*W*earing VR glasses, viewers move through the multi-layered landscapes and universes of *Heartbreak and Magic*'s cosmic quantum world in an immersive experience. The work, which Heaney developed from her own experiences of personal grief and sudden loss, invites us to reflect on what quantum physics can tell us about life and death. What remains of existence in a world where time isn't linear, where future and past exist simultaneously? *Heartbreak and Magic* allows us to experience spiritual moments of connectedness with ourselves. While Heaney unsparingly allows us to share in

11
Karen Barad in her lecture "On Touching: The Alterity Within," Gerrit Rietveld Academie at Stedelijk Museum Amsterdam, March 21-24, 2018, https://www.youtube.com/watch?v=u7LvXswjEBY. Accessed March 26, 2024.

12
Libby Heaney in one of her Instagram posts. https://www.instagram.com/Libby_Heaney /?hl=en. Accessed March 26, 2024.

her pain through the 'magical' perspective of quantum reality, she also creates a space where constant flux and change provide comfort, inviting us into a metaphysical world that transcends death. Karen Barad describes virtual particles as real but non-existent, virtuality as the indeterminacy of being/non-being. [11] In her virtual world of *Heartbreak and Magic*, Heaney achieves a tangible rendering this complex philosophical notion. Or as the artist herself says: 'Reality, at its most basic, is queer, is non-binary, is shapeshifting and this Newtonian world we live in an illusion'. [12]

Sabine Himmelsbach
LIBBY HEANEY: QUANTENSUPPE

Wenn ich erforsche, was jedwede Technologie durch Kunst erreichen oder nicht erreichen kann, greife ich häufig zu Konzepten aus der Quantenphysik, um auf diese Weise Pluralitäten und Verschränkungen zwischen Technologie, der Welt und uns selbst zu verstehen. Es bestehen Verbindungen zwischen einzelnen Facetten der Realität, die wir uns nie hätten träumen lassen. Ich bin mir sicher, dass sie verändern werden, wie Menschen die Welt und unseren Platz in ihr wahrnehmen und verstehen.

Libby Heaney

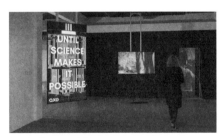

Ausstellungsansicht

Die Ausstellung Quantensuppe der britischen Künstlerin und promovierten Quantenphysikerin Libby Heaney am HEK fokussiert auf Werke, die mit dem Quantencomputer erstellt wurden und dessen Funktionalität und Bedeutung für die Gesellschaft und die Kunst thematisieren. Der Begriff »Quantensuppe« mag auf den ersten Blick ironisch erscheinen, da er nichts Konkretes beschreibt, sondern eher darauf verweist, wie es den meisten Laien gehen mag: Man hat von Quantencomputern und Quantencomputing gehört, weiß aber kaum etwas über diese komplexe Technologie, in die derzeit viel Geld investiert wird. Obgleich diese Lesart intendiert ist, verweist der Ausstellungstitel auch auf ein grundlegendes Selbstverständnis einer neuen Weltwahrnehmung durch

1
Karen Barad, Vortrag
»On Touching: The
Alterity Within«,
Gerrit Rietveld
Academie at Stedelijk
Museum Amsterdam,
21.–24. März 2018,
https://www.youtube.
com/watch?v=u7LvXs-
wjEBY.

2
Ariane Koek,
Entangle: Physics and
the Artistic Imagi-
nation, Berlin 2019,
S. 17.

3
Paul Thomas,
Quantum Art and
Uncertainty, Bristol
2018.

die Quantenphysik, das Heaney mit ihren Werken auf immer neue Art und Weise thematisiert und in unterschiedlichen Formaten, von immersiven Installationen, Spiel-Engines bis hin zu Aquarellen, skulpturalen Glasobjekten und Virtual Reality zum Ausdruck bringt. Als Quantenphysikerin hat sie selbst acht Jahre lang das Konzept der Quantenverschränkung erforscht, also wie sich Objekte gegenseitig beeinflussen können, auch wenn sie durch große Entfernungen getrennt sind, und wie die Quantenverschränkung für die Quanteninformationsverarbeitung genutzt werden kann. In ihrer künstlerischen Praxis ist es Heaney ein Anliegen, die mikroskopischen Phänomene einer pluralen Quantenwelt in einer scheinbar fixen und begrenzten makroskopischen Realität neu zu denken. In diesem Sinne ist der Begriff »Quantensuppe« auch als Ursuppe zu verstehen, als Materie, aus der alles entsteht. Die Physiker*in und Philosoph*in Karen Barad spricht in Bezug auf Quantenwelten von einer »soup of indeterminacy« (Suppe von Unbestimmtheit),[1] denn in der Quantenphysik wird Realität erst durch Messen ins Leben gerufen. Erst dann werden alle anderen Möglichkeiten, die in der Quantenrealität zeitgleich bestehen, zerstört oder ausgelöscht. In dieser Ursuppe einer Quantenrealität beziehungsweise eines Quanten-Multiversums ist alles fluid, non-binär und variabel, und genau diese Zuschreibungen sind es, die Heaney interessieren und deren Qualitäten sie für ihre künstlerische Praxis und die Entwicklung einer eigenständigen künstlerischen Sprache nutzt.

Ariane Koek, die in ihrem Beitrag für diese Publikation auf die Geschichte und Bedeutung der Quantenphysik für die Kunst eingeht, spricht in Bezug auf die Quantentheorie vom »Zeitalter der neuen Phänomenologien«[2] und der Künstler und Theoretiker Paul Thomas schreibt in seinem Buch Quantum Art and Uncertainty davon, wie die Quantentheorie die Art und Weise verändern wird, wie wir die Realität, unsere Beziehung zur Umwelt, zu unseren Mitmenschen und Tieren verstehen.[3] Heaney gilt als Pionierin in der künstlerischen Arbeit mit funktionsfähigen Quantencomputern, die nicht auf der binären Logik von 0 und 1, sondern auf Quantum Bits (oder Qubits) basieren, die verschiedene Zustände und Möglichkeiten gleichzeitig verarbeiten können. Denkt man an die exponentielle Rechenkapazität von Quantencomputern und ihr Potenzial, Ressourcen effizienter umzuverteilen oder komplexe ökologische Probleme zu lösen, erscheinen die Möglichkeiten nahezu

4
Viele dieser Sätze übernahm Libby Heaney von bestehenden Quantencomputing-Unternehmen wie Google, IBM oder zahlreichen anderen Start-ups der Branche.

magisch. Gleichzeitig besteht die Gefahr, dass diese Technologie den Überwachungskapitalismus noch weiter befördern wird und unsere Datensicherheit endgültig zunichtemacht. Diese Ambivalenz ist Heaney deutlich bewusst und genau deshalb setzt sie sich für den Umgang mit dieser Technologie vonseiten der Kunst ein, um hier für eine breite gesellschaftliche Auseinandersetzung zu werben und gleichzeitig die Magie der Quantenphysik für ein neues fluides, queeres, non-binäres Verständnis unserer Realität zu erkunden.

»Are you ready« fragt sie uns gleich beim Eintreten in die Ausstellung in ihren Werken QX Extended Advertisement und QX Product Launch Video (beide 2022). Sind wir bereit für eine Quantenwelt? Und wem wollen wir die Gestaltung dieser Welt überlassen? Die zuvor beschriebene Ambivalenz von unglaublichem Potenzial und inhärenten Gefahren der Nutzung dieser mächtigen Technologie wird in den beiden Videos thematisiert.

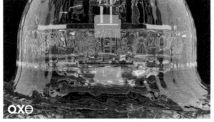

QX Product Launch Video, 2022

Dafür schuf Heaney ein fiktives Quantencomputer-Unternehmen unter dem Namen »QX« (Quantum eXperience), das wie andere Firmen im Rennen um die fortschreitende technologische Revolution im Bereich Quantencomputing seine Kompetenz propagiert wie auch die Heilsversprechen der neuen Technologie anpreist. »Reach Your Full Potential« steht auf den Bildschirmen zu lesen oder »We Are Accelerating the Future of Quantum Together«.[4] Die Einblendungen von Heaneys Werk Ent-, das gleich im Anschluss zu sehen ist, sind eingebettet in Animationen von Quantencomputern mit ihren eindrücklichen goldenen Gehäusen, die eine typisch kommerzielle Ästhetik und die Marketingstrategien von Big-Tech-Unternehmen parodieren. Die Fiktion des immerwährenden technologischen Fortschritts wird schnell durchbrochen, wenn kleine Bildstörungen und Glitches auftauchen, die Gehäuse der Quantencomputer von Schleim überzogen werden und der Sprechertext sich zunehmend verlangsamt und fehlerhaft wird. Die beiden Werke setzen den Ton für die Ausstellung und nehmen die komplexe Ausgangslage kritisch und ironisch in den Blick. In beiden Werken verwebt Heaney Fakten und Fiktionen und lädt die Betrachter*innen dazu ein, über die Zukunft des Quantencomputings und seiner gesellschaftspolitischen Bedeutung nachzudenken. Gleichzeitig lässt die Künstlerin die Prinzipien einer Quantenrealität weg

5
Unter Superposition versteht man die Fähigkeit von Quantenpartikeln, sich in mehreren Zuständen gleichzeitig zu befinden, bis sie gemessen werden.

vom Binären hin zum Fluiden und Pluralen mit allen Unbestimmtheiten und fließenden Kategorien visuell anschaulich werden.

In der immersiven 360-Grad-Videoinstallation Ent- (2022) tauchen die Betrachter*innen in eine mögliche Quantenwelt ein. Inspiriert von der zentralen Tafel des Triptychons Der Garten der Lüste (ca. 1490–1510) von Hieronymus Bosch schuf Heaney eine Welt, die von Szenarien und Kreaturen bevölkert wird, die an Boschs mittelalterliche Bildschöpfungen und Bestiarien angelehnt sind. Ihre eigenen Aquarelle dienten wiederum als Vorlagen, die sie einscannte und durch einen selbst geschriebenen Quantencode bearbeitete, um daraus visuelle Effekte und dreidimensionale abstrakte farbige Strukturen entstehen zu lassen. Auf der Grundlage der nichtlokalen Signaturen der Quantenverschränkung zerfallen diese Strukturen in einzelne Teilchen, strömen durch den Raum oder fügen sich neu zusammen. Aquarell als Medium wurde von der Künstlerin bewusst gewählt, da das Zerfließen und Ineinanderfließen von Farben mit Wasser für Heaney die Ambivalenz und Fluidität von Quantenpartikeln ideal widerspiegelt. Alles ist im Fluss stetiger Veränderung – die Betrachtenden erleben eine immersive Bildwelt, zoomen in Objekte hinein, die sich selbst als neue Welten entpuppen, tauchen in eine Unterwasserwelt und erleben die Fragmentierung und Dekonstruktion von Objekten. Dazu flüstert Heaneys Stimme Wortpaare auf Englisch und Deutsch, die den Titel Ent- auf unterschiedliche Weise ergänzen, wie »entanglements« (Verschränkungen), »entdecken« oder »enter«, die auf die Prinzipien einer mikroskopischen Quantenwelt verweisen und gleichzeitig die Offenheit ausdrücken, die der Titel suggeriert. Ent- überlässt die Entscheidung den Betrachtenden, zu welchem Begriff sich »Ent-« entwickeln könnte. So wie die Sprache werden auch die Bilder plural, schichten und überlagern sich, fangen an zu pulsieren und verweisen auf die gleichzeitigen Zustände (Superposition[5]) einer Quantenwelt, die uns die Künstlerin bildhaft anschaulich werden lässt.

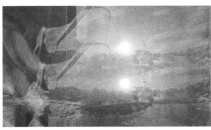

Ent-, 2022

Auch in Ent- werden die Ambivalenz und Glaubenssysteme rund um Quantencomputer in den Blick genommen. Hieronymus Boschs Triptychon verweist auf die parallele Darstellung von Himmel und Hölle, und wie in Boschs Gemälde

Freuden des Lebens und die drohende Gefährdung nah beieinanderliegen, so steht auch der Quantencomputer für eine Technologie, deren Potenzial und Gefahren in der zukünftigen Entwicklung noch offen sind. Entsprechend mäandert Ent- poetisch zwischen Entstehen und Auflösung und rückt dabei die Fluidität und Pluralität aller Materie in den Fokus. Amira Gad spricht in ihrem Beitrag in dieser Publikation vom Konzept der Entformung (»un-shaping«), also einer Welt, in der es keine Grenzen gibt und die nicht formbar ist.

Während in Ent- die immersive Erfahrung im Vordergrund steht, lädt Heaney die Betrachtenden in Ent- (many paths version) (2022) dazu ein, ihre Welt mittels eines Game-Kontrollers eigenständig zu erkunden.

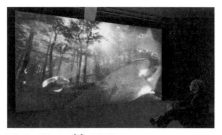

Q is for Climate (?), 2023
Ausstellungsansicht

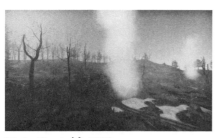

Q is for Climate (?), 2023

Ein neues quantenbasiertes Verständnis unserer Umwelt legt die Arbeit Q is for Climate (?) (2023) nahe und stellt schon im Titel die Frage, ob uns der Quantencomputer den Weg aus der Klimakrise weisen könnte. Simulierte Landschaftsbilder vermischen sich mit Animationen von Gehäusen eines Quantencomputers und den Tentakeln eines Oktopusses. Wassergeräusche verweisen auf den Urzustand unserer Welt; die Bilder werden überlagert von schwarzem ölartigem Schleim, der sich über die Landschaft ergießt, bewegt von einem pulsierenden Sound. »Quantenpartikel verwandeln sich. Ihre Eigenschaften entstehen tatsächlich erst durch Verschränkungen mit der restlichen Umwelt«,[6] schreibt Heaney. Angedeutet wird dies in der Arbeit durch die Vielzahl von Überlagerungen und Perspektiven, die auf die nichtlineare Zeit in der Quantenphysik verweisen, wo Bewegungen von Partikeln in alle Richtungen gleichzeitig möglich sind. Statt das Potenzial von Quantencomputern zu nutzen, um den extraktiven Kapitalismus unserer Zeit weiterzutreiben, könnte das Prinzip der Quantenverschränkung uns als Beispiel dienen, wie ein non-binäres, queeres und plurales quantenbasiertes Weltverständnis, in dem menschliche und nichtmenschliche Akteure gleichberechtigt sind, uns ein besseres Miteinander mit unserer Umwelt ermöglicht.

7
Michel Orrit,
»Quantum Light
Switch«, in: Nature
Physics, 3, 2007,
S. 755–756, https://
www.nature.com/
articles/nphys766.

Die zwei Glasobjekte Supraphrodite (i) und Supraphrodite (ii) (beide 2024) sind neu für den Kontext der Ausstellung entstanden. Die Materialität von Glas beschreibt Heaney als spiegelbildlich (in Bezug auf die Temperatur) zu Quantenpartikeln, und dennoch sind ihre Eigenschaften vergleichbar: Glas verflüssigt sich, wenn es erhitzt wird, und im Gegensatz dazu verflüssigen sich Quantenpartikel (Atome und Moleküle, die sich anders verhalten als die sogenannten festen Körper, die wir in der makroskopischen Welt sehen) und werden bei extremer Kälte wellenförmig (weshalb Quantencomputer bei Temperaturen um -270 Grad operieren). Glas verlangsamt Lichtwellen durch Brechung, und Quantenpartikel können die Bewegung des Lichts einfrieren und wieder loslassen.[7] Der Prozess der Herstellung von Glasobjekten kann zufällig, unvorhersehbar und organisch

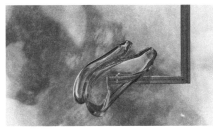

Supraphrodite (ii), 2024, Ausstellungsansicht

sein. Beide Glasobjekte bestehen aus zwei transparenten Glaszellen, die miteinander verbunden sind. Ihre Form erinnert an erstarrte flüssige Formen. Die beiden Glasobjekte produzieren zahlreiche Brechungen und Reflexionen des Lichts der weiteren Videoarbeiten im Raum und erlauben damit immer wieder neue Perspektiven und Blickwinkel für die Betrachter*innen. Die Titel verweisen auf Aphrodite, die Göttin der Schönheit und Liebe, dem Mythos nach aus weißem Schaum geboren. Der Name Supra leitet sich von der lateinischen Vorsilbe für »über« oder »darüber hinaus« ab, ein weiterer Vergleich zum Thema Entgrenzung und Verschränkungen in einer Quantenrealität.

In der 3-Kanal-Videoinstallation slimeQrawl (2023) verwendet Heaney Schleim als Metapher für Quantenpartikel, da dieses Material sich wunderbar dafür eignet, die fluide und formverändernde Materialität von Quantenpartikeln zu visualisieren, wie Paul Luckraft und Julia Greenway in ihrem Beitrag beschreiben. In slimeQrawl wird Schleim in Nahaufnahmen mit Händen geknetet und von Heaney in den Mund genommen. Schleim rinnt in Renderings aus den Fugen von Modellen heutiger Quantencomputer und ergießt sich über das gesamte Bild. Für den Entstehungsprozess des Videos arbeitete Heaney mit dem 5-Qubit-Quantencomputer von IBM und setzte eine von ihr entwickelte Technik ein, um

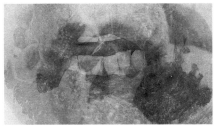

slimeQrawl, 2023

die wellenförmige Signatur verschiedener Arten von Quantenverschränkung aufzudecken. Das Ergebnis der parallelen, überlagerten Bilder spiegelt die Prinzipien von Quantenzuständen wider. Schleim wird zu einer »kollektiven Intelligenz«, einem »kollektiven Körper« jenseits fester Grenzen. [8] Über den Schleim wird eine Verkörperung und Körperlichkeit thematisiert, die die Bilder der faszinierenden Maschine des Quantencomputers mit Bildern von menschlichen Körpern in einen direkten Bezug setzt und einen Einklang herstellt.

8
Libby Heaney in einem Instagram-Post, https://www.instagram.com/Libby_Heaney_/?hl=en.

9
In einem Gespräch mit der Autorin verwies Libby Heaney darauf, dass die Arbeit auch eine Reaktion beziehungsweise Verarbeitung ihrer Kindheit sei. Entsprechend lässt sie sich auch als Antwort auf 18 Jahre Bevormundung lesen, insbesondere, da die Dauer des Videos genau 18 Minuten beträgt – eine Minute für jedes Jahr des Erwachsenwerdens. Aus dieser Perspektive gesehen ist Never Too Much auch ein Befreiungsschlag und eine Selbstermächtigung.

Körperlichkeit und Quantenrealität werden auch in den drei Videoarbeiten What's Love Got To Do With It, Never Too Much und Please Don't Cry (alle 2023) thematisiert, die alle mit starken persönlichen Gefühlen sowie Erinnerungen an Heaneys eigene subjektive Erfahrungen zu tun haben und in denen sie sich damit auseinandersetzt, wie Trauma und Erinnerung einen quantenähnlichen Charakter haben. In What's Love Got To Do With It wird in einer oft bewusst unscharfen Überlagerung von Bildern Schleim geknetet und durch manikürte Fingernägel gepresst. Wie beim Drücken eines Stressballs scheinen sich hier Aggressionen zu entladen und gleichzeitig erweckt die Arbeit den Eindruck, dass etwas anderes (ein Monster?) zum Vorschein kommt. In Never Too Much kommt Schleim aus dem Mund, wird konsumiert und wieder ausgespien, immer im Fluss. Obwohl es der Titel negiert, scheint die Erfahrung doch ein Zu Viel zu beinhalten; die Geste des Aufnehmens und Ausscheidens des Schleims erscheint auch als ein Moment des Würgens und Überfordertseins. [9] In Please Don't Cry sehen wir die Nahaufnahme eines geschminkten Auges. Tränen sind zu sehen und wir werden gewahr, dass die Person, wieder ist es Heaney selbst, weint. [10] Die Arbeit entstand in Trauer um und in Erinnerung an die verstorbene Schwester und stellt eine Beziehung zu dem Werk Heartbreak and Magic her, das sich ebenfalls mit diesem Verlust beschäftigt.

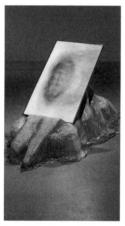

Never Too Much, 2023, Ausstellungsansicht

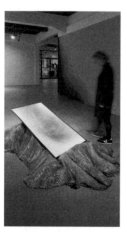

Please Don't Cry, 2023, Ausstellungsansicht

10
Please Don't Cry ist
34 Minuten lang.
Heaneys Schwester
war 34 Jahre alt, als
sie starb.

Alle drei Videoarbeiten beeindrucken durch diese starke Intimität, die noch verstärkt wird, da die Betrachtenden in eine körperliche Relation zu den Videos gebracht werden, indem alle drei Videomonitore in organische Strukturen beziehungsweise sockelartige Gebilde eingebettet sind, die die Tonalität und Farbigkeit der Werke aufnehmen.

"all my colours for you", 2024, Detail

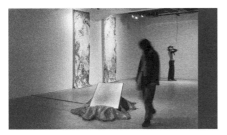

Ausstellungsansicht

Den Abschluss der Ausstellung bildet die Virtual-Reality-Arbeit Heartbreak and Magic (2024), die von den beiden großformatigen Aquarellen "all my colours for you" (2024) und God Rays Tick Tick (2023) begleitet wird. Inspirationen und Ideen für ihre Werke erarbeitet Heaney oft im Medium des Aquarells, dessen fluide Eigenschaften einen idealen Bezug zur Pluralität der Quantenrealität herstellen. Die beiden Aquarelle beinhalten Bildfindungen, Skizzen, Kommentare und textliche Anmerkungen, die den Recherche- und Entstehungsprozess von Heaneys künstlerischer Praxis anschaulich machen. Bewegungs- und Atemübungen gehören ebenso zu dem experimentellen Prozess der Werkgenese wie Schreiben, Zeichnen und Malen oder das Schreiben von Quantencomputercode, mit dem die analogen Daten bearbeitet und transformiert werden.

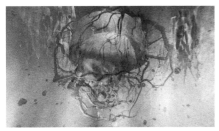

Heartbreak and Magic, 2024

Heartbreak and Magic lässt die Betrachter*innen mittels VR-Brille in eine kosmische Quantenwelt eintauchen, in der sie durch eine vielschichtige Landschaft beziehungsweise Universen geleitet werden. Heaney verarbeitet in diesem Werk ihre eigenen Erfahrungen mit persönlicher Trauer und plötzlichem Verlust. Die Arbeit lädt dazu ein, über das nachzudenken, was uns die Quantenphysik über Leben und Tod vermitteln kann. Was bleibt von der Existenz in einer Welt, in der es keine lineare Zeitvorstellung gibt, sondern Zukunft und Vergangenheit gleichzeitig vorhanden sind? In Heartbreak and Magic erleben wir spirituelle Momente der Verbundenheit mit uns selbst. Mit schonungsloser Offenheit lässt uns Heaney an ihrem eigenen Schmerz teilhaben, aber es gelingt ihr auch, den Betrachter*innen durch die »magische«

11
Barad
21.–24.03.2018
(wie Anm. 1).

12
Libby Heaney in
einem Instagram-
Post, https://www.
instagram.com/Libby_
Heaney_/?hl=en.

Perspektive einer Quantenrealität, die sich in ständigem Wandel befindet, eine transzendente Erfahrung zu vermitteln, eine tröstliche Verbindung zu einer metaphysischen Welt, auch über den Tod hinaus. Karen Barad spricht davon, dass virtuelle Teilchen real, aber nicht vorhanden seien; dass Virtualität die Unbestimmtheit von Sein/Nichtsein sei. [11] In Heartbreak and Magic schafft es Heaney, in ihrer virtuellen Welt dieses komplexe philosophische Verständnis sinnlich erfahrbar zu machen. Oder wie die Künstlerin selbst sagt: »Im Grunde ist die Realität queer, non-binär, wandelbar, und diese newtonsche Welt, in der wir leben, eine Illusion.« [12]

Amira Gad
THROUGH THE LOOKING GLASS – LIBBY HEANEY'S QUANTUM REALITY

1
Melanie Bayley (December 16, 2009). "Alice's adventures in algebra: Wonderland solved", New Scientist. [https://www.newscientist.com/article/mg20427391-600-alices-adventures-in-algebra-wonderland-solved/]. Accessed March 8, 2023.

'Through the looking glass' springs to mind when diving into Libby Heaney's quantum world: a place that suddenly appears unfamiliar, as if things were turned upside down. The phrase was popularised by Lewis Carroll's children's novel *Alice's Adventures in Wonderland* (1865) and its sequel, about a young girl named Alice who falls through a rabbit hole into a fantasy world of anthropomorphic creatures. Some have asserted that the novel satirises 19th century mathematics – Carroll was also a mathematician.[1] Heaney's work is similarly supported by another technical background. Having been a quantum physicist, she sought out the arts to make sense of the world without the limitations, perhaps, of science, where instead creativity could take her ideas further. The closer I engaged with her work, the deeper I fell down the rabbit hole of her quantum reality.

Quantum Reality

Technology has seamlessly integrated itself into artistic expression, just as it is omnipresent and deeply intertwined with daily life. Yet to interpret Heaney's work within

2
Web3 is an idea for a new iteration of the World Wide Web based on the block-chain, which incorporates concepts including decentralisation and token-based economics.

3
Noam Segal with Agnieszka Kurant, *Notes on the Index in Accelerated Digital Times*, Pompeii Commitment: Archaeological Matters, website. [https://pompeii-commitment.org/en/commitment/noam-segal/#02]. Accessed March 8, 2024.

4
slimeQrawl, artist's website. [https://LibbyHeaney.co.uk/artworks/slime-qrawl/]. Accessed March 9, 2024.

the art & tech framework only creates a ping-pong effect among categorizations that are not attuned to quantum's non-binary thinking. Heaney's use of quantum goes beyond utilising technology as a medium and a critical reflection on quantum computing. Rather, the artist's work embodies quantum thinking and feeling and attempts to capture the complexity of quantum realities. Heaney applies quantum tools in different ways from scientists or market-driven initiatives that aim to make the technology even faster and have real-life applications for all areas of society. Big Tech corporations such as Google, IBM, Microsoft, Intel, or Amazon are in the capitalist race to build the first fully operating quantum computer. As the artist has often told me, the quantum computer would be a real game changer, moving from Web3 [2] to WebQ (Web Quantum). Guggenheim curator Noam Segal writes:

It would also affect our dependency on minerals like lithium, have major environmental impacts, and help develop biodegradable plastics or carbon-free aviation fuel. The sad news is that it is not being developed to mitigate the effects of climate change. Most quantum computation, like the early Internet, is geared toward military usage. [3]

A full-scale quantum computer has the ability to decrypt all the RSA encryption used. RSA encryption is one of the oldest public-key cryptosystems that is widely used for securing data transmissions. On that level alone, one can already imagine how quantum computing can be weaponised.

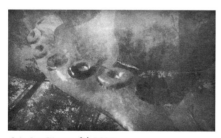

Q is for Climate (?), 2023

L uckily, artists can still be relied on to offer alternative perspectives. Indeed, for Heaney, quantum is a lens through which to understand the world. In her video works *Q is for Climate (?)* where she questions how quantum computers can impact the climate crisis, and the three-channel video installation *slimeQrawl* (both 2023), for instance, new footage was created through IBM's 5 qubit quantum computer, layering and remixing video clips in waves mirroring the fluid behaviour of quantum particles. [4] In contrast with step-by-step video editing, she writes code to create quantum entanglement – explained in more detail later in this text – on a quantum computer that then generates a video. Different

5
I use the term assimi-
lation as I believe that
the technology in its
current form adapts
and learns from a ma-
jority and prevailing
knowledge base.

types of entanglement give different rising and falling wavelike patterns of the videos appearing or disappearing. The resulting work in *Q is for Climate (?)* shows 32 videos playing at once (mirroring how a quantum computer operates by processing several pieces of information in parallel) of polluted waters, toxic fumes, or an octopus-like creature (a self-portrait of Heaney). Some videos rise to the top and others decay in a non-linear narrative that offers multiple escapes from an apocalyptic end.

*H*eaney's approach to quantum is kaleidoscopic: complex, layered, coloured. It's neither singular nor binary. Quantum becomes an infinite palette that she can mould, paint, animate, and bring to life in *this* reality and in various ways through her work. Heaney works with IBM's cloud-based quantum computing, made partly accessible in 2019 when she started to experiment with it and to explore what quantum reality would look like and how one might assimilate a depiction and an experience of that multiverse. The difficulty and the complexity lie in the fact that quantum computing is nothing like any computer known today – they are ontologically different, and their realities are the opposite of each other.

*L*ike algorithms, computing is still binary. Artificial intelligence (AI) can only make use of the knowledge base that is already here. AI is a form of assimilation,[5] which has the ability to take in the prompts from humans and generate information based on that cumulative data. It will, for instance, make use of prompt A to generate idea Z, based on all the letters of the alphabet as its dataset and context. AI can learn from the past and be trained to have random moments, but it does require humanity's push to imagine the future. As such, it assimilates an understanding of the future based on the past. Its modus operandi is linear.

*Q*uantum computing, on the other hand, takes the rules of quantum physics to process information, allowing it to have a faster processing power that runs all possibilities in parallel. Today's computers run those sequentially step-by-step. On a technical level, quantum computing is based on a qubit, or a quantum bit, while classical computing operates on a 2-bit register: binary digits consisting of 0s or 1s. Just as a bit is the basic unit of information in a classical computer, a qubit is the

6
Segal with Kurant,
Notes on the Index in Accelerated Digital Times.

7
David L. Chandler (August 25, 2023). "Could the Universe be a giant quantum computer?" *Nature*. [https://www.nature.com/articles/d41586-023-02646-x]. Accessed March 13, 2024.

basic unit of information in a quantum computer. The nature and behaviour of these qubits (as expressed in quantum theory) form the basis of quantum computing.

The two most important principles of quantum computing that set it apart from classical computation are superposition and entanglement – and Heaney holds a PhD in quantum physics specializing in the latter. According to quantum law, in a superposition of states particles behave as if they were in two or more states simultaneously. They can process information in parallel by taking superpositions of both 0 and 1. Quantum entanglement allows qubits that are separated by incredible distances to coherently interact with each other instantaneously. Taken together, quantum superposition and entanglement create an unprecedented computing power. Quantum computers are different not only in the way in which they operate, but also in that they are neither linear nor predictable. They are multi-dimensional as the movement of electrons in quantum computation can be entangled and superposed and exist simultaneously in many places. A quantum computer can make an infinite number of connections, in parallel, at a speed that human intelligence will never be able to achieve.

This technical explanation of quantum computing is an important step in accessing another level of understanding Heaney's work. From a conceptual perspective, a quantum computer's modus operandi offers a different idea of temporality: it expands, unfolds, and multiplies. It resembles human culture in that it moves in multiple different and unexpected directions at once. Not many would want to think of the future as calibrated only on past patterns: while most 'conceptualise historical movement as linear and continuous, very few would say it is predictable'.[6] One might even propose that quantum computing is a generative form of output and AI is based on cumulative learning. The differences in technologies could be explained as far as saying that quantum computing is a natural, rather than artificial, form of intelligence – that 'the universe is a quantum computer'.[7]

In this sense, quantum computing is otherworldly (or is it godly?). And it is with that sense of otherworldliness that Heaney's work grapples. It makes tangible and visible an experience of quantum reality. But in order to do this, it must

"Worldbuilding", Wikipedia. [https://en.wikipedia.org/wiki/Worldbuilding#cite_note-15] Accessed March 9, 2024.

follow the laws of classical physics, translate it back into Newtonian terms and the dimension humanity inhabits. And so a quantum image is a remnant of an inaccessible reality and one of many interpretations of the multiverse. Heaney frequently references Umberto Eco's book *The Open Work* (1962), in which he connects quantum particles and their pluralities to the notion of an artwork holding many distinct meanings. Similarly, her work is open to multiple interpretations in line with the ethos of quantum thinking. She has incorporated this thinking in her titles, such as *Ent-* (2022), incomplete and open to the viewer's interpretations.

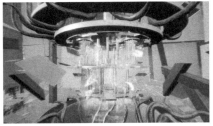

Ent-, 2022

*H*eaney's practice not only reveals the binary nature of macroscopic reality but also how the quantum world might look if one were able to observe it. The infinite interconnectedness can perhaps be a tool to make sense of Newtonian reality. Even though mostly inaccessible, quantum reality is another world that enables a new way of seeing and perceiving. Just like Alice in Wonderland, one is projected into an alternate reality and taken through an eye-opening journey. It might sound like fiction, except it's not; it's science and Heaney's work unravels the foresight that science-fiction can have.

World un-shaping

*F*iction can envision a new world, from geography to fauna to language to technology. Within artistic discourse, particularly that geared towards practices at the intersection of emergent technologies, the term 'worldbuilding' – constructing an imaginary universe – is often used to discuss works created using game engines. Heaney also uses game engines, necessary tools in this inter-dimensional process of translation from quantum reality into the Newtonian world. The etymology of worldbuilding connects with the laws of physics, as the term was first used in Arthur Eddington's *Space, Time, and Gravitation: An Outline of General Relativity Theory* (1920) to 'describe the thinking out of hypothetical worlds with different physical laws'. [8] Heaney, however, prefers to talk about 'world un-shaping', as it seems more attuned to quantum. If a quantum

computer's qualities can be characterised as atempo-
ral, discontinuous, and expansive, then how can you
begin to *build* that reality? It is not embedded within (Newto-
nian) reality, and the context as known and inhabited. Within
the multi-dimensional expanse, any 'building' would dissolve
back into the bulk almost immediately (like the forms in, say,
Heaney's work *slimeQrawl*). Instead, it has multiple dynamic
lives, paths, and portals on several planes all at once.

*T*he idea of world un-shaping suggests that there are no
borders, that there is no worldly box to shape. It col-
lapses the boundaries between online and physical, reality
and fiction, but most importantly the infrastructure of how
knowledge is constructed. In a way, a quantum computer is
like a black box, a system that can be viewed in terms of in-
puts and outputs without any knowledge of its internal work-
ings. It is not surprising that when it comes to the presenta-
tion of her work, Heaney opts for black-box-like installations
as with the aforementioned 360-degree projection *Ent-*. In
this artwork, which is an interpretation of the central panel
of Hieronymus Bosch's famous triptych *The Garden of Earthly
Delights* (c. 1490–1510), Heaney uses a self-written quantum
code to distort and animate her own watercolour paintings. The
result is then brought together and animated using a game en-
gine, and forms a sequence of overlaid images that transform
into a reimagined and dreamlike garden in which the immersed
audience morphs into the figures in the painting. There are
moments of (quantum interpretation of) 'entanglements' that
can be perceived when experiencing the work, brief animated
blurs or moments of blitz. On a conceptual level, parallels can
be drawn between Bosch's triptych and quantum physics and
computing, given that technology can be seen as a new religion
promising life beyond the body.

I am tempted to link the black box to the more art-historical
concept of tableau vivant (living picture). Are immersive
installations (VR or 360, for instance) new forms of tableaux
vivants? This concept was explored by several art theorists,
including Jean-François Chevrier, who examined the relation-
ship between photography and painting, suggesting that
photographers create tableaux vivants through staged scenes
that reference art history. Chevrier emphasises the interplay
between reality and fiction and the ways in which they chal-

9
Sos Agaian and
Artyom Grigoryan,
"Brief Notes on the
Possibility of Copying
Cubits in Quantum
Systems", *WSEAS
Transactions on
Circuits and Systems*
21 (2022): 20–25.
[https://wseas.com/
journals/cas/2022/
a045101-002(2022).
pdf]. Accessed
March 9, 2024

lenge traditional notions of photographic truth. As such, a tableau vivant asks for a reconsideration of the perceptions of reality, representation, and artistic tradition. Similarly, Heaney's work conveys her disbelief in truth, in questioning understandings of reality and experimenting with conventional art making.

*A*t the core of her artistic practice, in line with quantum thinking, is a deconstruction of one's upheld realities and as such a process of un-shaping and even unlearning. Copying unknown information is not possible within quantum computing. To be more specific, this process of making an exact copy of information without altering its original state is referred to as 'quantum cloning' and is forbidden by the laws of quantum mechanics. [9] To generate within quantum reality is to create something else without repeating or copying what has been done in the past. Unlike AI, it doesn't need the past to think forward. The pedagogy of unlearning that has been necessary within artistic discourse is already intrinsic to quantum thinking.

Dreamlike

*T*here is something to be said about the technology of image making. In Heaney's case, drawing informs several of her works, be they VR, video or 3D simulations. At the same time, the question has arisen as to how she could generate visuals that would not otherwise be generated using digital technologies. What aesthetics can you make using the pluralities embodied by quantum?

*H*er watercolours often depict hybrid forms or creatures in various colours and images that are overlaid. The artist has told me that she started working with watercolours at the same time as she started working with quantum computing, the practices going hand in hand. The reasoning behind this is that she wanted to process an image using a quantum computer to see how it would affect the image visually, and when thinking about which one to choose, she opted for making a watercolour image. She explains that 'water is like a quantum particle, it is wave-like, floods the page and spreads out and

interferes.' I would add that the way watercolour op- erates has something magical in its unpredictability, resulting in a dreamlike quality and an aesthetic that returns in many of Heaney's works.

*I*n her practice, Heaney also experiments with slime, as featured in *slimeQrawl* (2023). In this work, she combines videos of slime and human and non-human bodies that melt in and out of one another whereby hybrid creatures and other familiar forms emerge. Slime has also appeared in her glass, sculptural, and spatial installations (including her show at arebyte Gallery in London) and during her public talks as a metaphorical materialization of quantum. As a swelling, expandable, and mouldable mucus, slime is otherwise referred to as a non-Newtonian fluid since it doesn't follow Newton's law of viscosity.

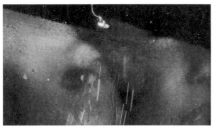

Heartbreak and Magic, 2024

*I*n quantum, the simple act of looking alters the state of reality. To go back to the science behind it: qubits are very sensitive to noise and environmental interactions that can disrupt its quantum state, causing it to decohere. It is fascinating to me that in spite of the limitations of perception of quantum reality, Heaney's practice (re-)creates quantum realities and an experience of them by going through a process of inter-dimensional translation. While quantum is used as an artistic medium, this translation emphasises affect, senses, emotions, and the performative nature of the work. *Heartbreak and Magic* (2024), the artist's latest experiment in bringing together VR and quantum computing, is an emotional VR experience that deals with her personal grief. It's an expression of the need for alternate realities and looks to quantum physics to gain an understanding of life and death. The dreamlike experience encapsulates the magic of the otherworldly to tackle the complexities of grief, grasp the incomprehensible and see how quantum can allow for a sense of empathy.

*H*eaney's work, like Alice's fantastical journey in Wonderland, plunges one into the ever-shifting realms of quantum computing, where realities morph and diverge. It prompts questions as to whether the quantum computer assumes a quasi-divine role. What Heaney suggests through her work is that one's perception of truth is inherently limited, and quan-

tum thinking challenges the notion of fixed realities.
But perhaps the other point is that the Newtonian
world in which one lives in is an illusion and a singular image /
interpretation from a much larger dynamic multiverse.

*H*er work epitomises a shift in attention around emergent
technologies, offering not only a reflection but also a
guide to dreaming differently about our world. Quantum reality
seems elusive and expansive, and one might never fully gain
hold of the intricacies of quantum realms. Yet through Heaney's
installations, VR works, painting, slime, and glassworks, it is
possible to catch glimpses through the quantum looking glass.
Heaney's work speaks to the senses on a deeply emotive level
that encapsulates an experience, or perhaps just a hint of its
essence – a small window into the vast expanse of quantum.
Artists, as pioneers of technological discourse, are poised to
influence understanding of and ways to use emerging tech-
nologies like quantum computing. And while the complexity of
quantum computers affords some time, the narrative of Alice
is a reminder that we are the arbiters of our own destiny, yet
to awaken fully from the dream. Thus, the question remains:
where does one go from here, still ensnared within the dream-
like haze of the current illusion? Just like Alice's Wonderland,
this is Libby's Wonderland.

IM SPIEGELLAND – LIBBY HEANEYS QUANTENREALITÄT

1
Melanie Bayley, »Alice's Adventures in Algebra: Wonderland Solved«, in: New Scientist, 16.12.2009, https://www.newscientist.com/article/mg20427391-600-alices-adventures-in-algebra-wonderland-solved/.

Wie im »Spiegelland«, denkt man, wenn man in Libby Heaneys Quantenwelt eintaucht: Die Welt erscheint hier plötzlich ungewohnt, als ob die Dinge kopfstünden. Die Vorstellung einer Parallelwelt im Spiegel wurde durch Lewis Carrolls Alice im Spiegelland bekannt, die Fortsetzung seines Kinderbuchklassikers Alice im Wunderland, in dem ein Mädchen durch einen Kaninchenbau in eine von anthropomorphen Wesen besiedelte Fantasiewelt hineinfällt. Einer Auffassung zufolge ist der Roman eine Persiflage auf die Mathematik des 19. Jahrhunderts, schließlich war Carroll auch Mathematiker.[1] Libby Heaneys künstlerische Arbeit verweist ebenfalls auf einen anderen Hintergrund. Als Quantenphysikerin fand sie den Weg in die Künste, um jenseits der Beschränkungen der Naturwissenschaften in der Welt Sinn zu suchen und um ihre Ideen mit kreativen Mitteln weiterzuentwickeln. Je intensiver ich mich mit ihrer Arbeit beschäftige, desto tiefer rutsche ich selbst in den Kaninchenbau ihrer Quantenrealität hinein.

Quantenrealität

So wie Technologie allgegenwärtig und tief mit unserem Alltag verwoben ist, so hat sie sich in den letzten Jahren auch nahtlos in künstlerische Ausdrucksformen integriert. Doch Heaneys Arbeit im Dunstfeld »Kunst & Technologie« einzuord-

2
Web3 ist eine Idee für eine neue Form des World Wide Web, die auf der Blockchain basiert und Konzepte wie Dezentralisierung und Token-basierte Wirtschaft integriert.

3
Noam Segal mit Agnieszka Kurant u. a., »Notes on the Index in Accelerated Digital Times«, in: Pompeii Commitment: Archaeological Matters, 2024, https://pompeiicommitment.org/en/commitment/noam-segal/#02.

nen, greift zu kurz und führt nur zu einem Ping-Pong-Effekt zwischen Kategorisierungen, die dem non-binären Denken aus der Quantenperspektive nicht entsprechen. Heaneys Auseinandersetzung mit den Quantenwissenschaften geht über den Einsatz von Technologie als Medium und über die kritische Reflexion des Quantencomputings hinaus. Vielmehr verkörpert ihr Werk ein Denken und Fühlen aus der Quantenperspektive und versucht, die Komplexität dieser Realitäten zu erfassen. Heaney wendet bestehende Quantentechnologien anders an als Wissenschaftler*innen oder marktgetriebene Initiativen, die darauf abzielen, diese Technologien zu beschleunigen und reale Anwendungen für alle Bereiche der Gesellschaft zu finden. Große Tech-Konzerne wie Google, IBM, Microsoft, Intel oder Amazon befinden sich im kapitalistischen Wettlauf um den Bau des ersten voll funktionsfähigen Quantencomputers. Wie Heaney selbst oft erklärt, wäre der Quantencomputer eine radikale Innovation, der Übergang vom Web3[2] zum WebQ (Web Quantum). Guggenheim-Kuratorin Noam Segal schreibt dazu:

[Dies] könnte sich auch auf unsere Abhängigkeit von Mineralien wie Lithium auswirken, hätte erhebliche Konsequenzen für die Umwelt und könnte zur Entwicklung von biologisch abbaubaren Kunststoffen oder kohlenstofffreiem Flugbenzin beitragen. Die traurige Nachricht ist, dass es nicht entwickelt wird, um die Folgen des Klimawandels abzumildern. Der Großteil der Quanteninformatik ist, wie das frühe Internet, auf militärische Anwendungen ausgerichtet.[3]

Ein vollwertiger Quantencomputer könnte zum Beispiel jede RSA-Verschlüsselung entschlüsseln. Die RSA-Verschlüsselung ist eines der ältesten Kryptosysteme mit öffentlichen Schlüsseln, weltweit zur Sicherung von Datenübertragungen verwendet. Schon auf dieser Ebene kann man sich vorstellen, wie Quantencomputing als Waffe eingesetzt werden könnte.

Glücklicherweise können wir noch immer darauf zählen, dass Kunstschaffende alternative Perspektiven aufzeigen. Für Heaney ist die Quantenmechanik eine Linse, durch die man die Welt verstehen kann. In der Videoarbeit Q is for Climate (?), in der sie die möglichen Auswirkungen von Quantencomputern auf die Klimakrise untersucht, und in der

4
Siehe slimeQrawl auf der Website der Künstlerin, https://libbyheaney.co.uk/artworks/slimeqrawl/.

5
Ich verwende den Begriff der Assimilation, weil die Technologie in ihrer jetzigen Form sich an bestehendes und vorherrschendes Wissen anpasst und daraus lernt.

3-Kanal-Videoinstallation slimeQrawl (beide 2023) wurde beispielsweise neues Filmmaterial durch den 5-Qubit-Quantencomputer von IBM generiert, der Videoclips in Wellen schichtet und neu mischt, und die so das fluide Verhalten von Quantenteilchen widerspiegeln. [4] Im Gegensatz zur linearen, schrittweisen Videobearbeitung schreibt Heaney Code, um Quantenverschränkung zu erzeugen. Dazu benutzt sie einen Quantencomputer, der basierend auf ihrem Code ein Video generiert. Unterschiedliche Arten der Verschränkung erzeugen verschiedene auf- und absteigende wellenförmige Muster der Videos, die erscheinen und wieder verschwinden.

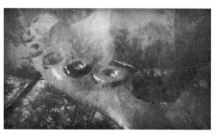

Q is for Climate (?), 2023

Die resultierende Arbeit Q is for Climate (?) besteht aus 32 Videos gleichzeitig, so wie ein Quantencomputer zahlreiche Informationseinheiten parallel verarbeitet: Bilder von verseuchten Gewässern, toxischen Gasen oder eines Oktopus-ähnlichen Wesens (ein Selbstporträt Heaneys). Einige der Videos treten in den Vordergrund, während andere zunehmend verfallen. Ihre Bewegungen bilden eine nichtlineare Erzählung, die an mehreren Stellen ein Entkommen vor dem apokalyptischen Ende bietet.

Heaneys Auseinandersetzung mit der Quantenwissenschaft ist kaleidoskopisch: komplex, vielschichtig und bunt, weder singulär noch binär. Die Quantenwelt wird zur unbegrenzten Palette, die Heaney mit ihrer Kunst in dieser Realitätsebene auf unterschiedlichste Weise formen, einfärben, animieren und beleben kann. Heaney arbeitet mit dem Cloud-basierten Quantencomputer von IBM, der 2019 teilweise öffentlich zugänglich gemacht wurde. Sie begann damit zu experimentieren und zu erforschen, wie die Quantenrealität aussehen könnte. Insbesondere beschäftigte sie, wie man sich der Erfahrung und Darstellung dieses Multiversums annähern könnte. Die Schwierigkeit und Komplexität dieses Unterfangens liegt darin, dass Quantencomputer ganz anders sind als alle heute bekannten Computer – die Systeme sind ontologisch verschieden, und ihre Realitäten stehen sich diametral gegenüber.

Algorithmen und Datenverarbeitung, wie wir sie heute kennen, sind immer noch binär. Künstliche Intelligenz (KI) kann nur auf die bereits vorhandene Wissensbasis zurückgreifen. KI ist eine Form der Assimilation, [5] in der Lage, Inputs

von menschlichen Akteuren zu verarbeiten und auf Grundlage dieser kumulierten Daten Informationen zu generieren. KI verwendet zum Beispiel die Aufforderung A, um basierend auf allen Buchstaben des Alphabets – die als Datensatz und Kontext dienen – die Idee Z zu erzeugen. KI kann aus der Vergangenheit lernen und darauf trainiert werden, manchmal den Zufall spielen zu lassen, aber sie benötigt menschlichen Anstoß, um sich die Zukunft vorzustellen. Sie eignet sich demnach ein Verständnis der Zukunft an, das auf der Vergangenheit basiert. Ihre Vorgehensweise ist linear.

Das Quantencomputing hingegen verarbeitet Information nach den Regeln der Quantenmechanik und stellt eine viel schnellere Datenverarbeitung in Aussicht, da alle Möglichkeiten parallel ablaufen. Heutige digitale Computer arbeiten sequenziell und schrittweise. Auf technischer Ebene bedeutet dies: Quantencomputer basieren auf dem Quantenbit, Qubit genannt, während klassische Computer mit einem 2-Bit-Register arbeiten: binäre Ziffern, die aus 0 oder 1 bestehen. So wie ein Bit die Grundeinheit der Information in einem klassischen Computer ist, ist ein Qubit die Grundeinheit der Information in einem Quantencomputer. Die Art und das Verhalten dieser Qubits (wie sie in der Theorie der Quantenmechanik beschrieben werden) bilden die Grundlage des Quantencomputers.

Die beiden wichtigsten Prinzipien der Quanteninformatik, die sie von der klassischen Informatik unterscheiden, sind Überlagerung und Verschränkung. Letztere war der Schwerpunkt von Heaneys Promotion. Nach den Gesetzen der Quantenmechanik verhalten sich Teilchen in einer Überlagerung von Zuständen so, als befänden sie sich in zwei oder mehr Zuständen gleichzeitig. Sie können Informationen parallel verarbeiten, indem sie gleichzeitig die Position von 0 und 1 einnehmen. Quantenverschränkung ermöglicht eine unmittelbare, kohärente Wechselwirkung von Qubits, die durch unglaubliche Entfernungen voneinander getrennt sind. Zusammengenommen ermöglichen die Zustände der Überlagerung und Verschränkung eine beispiellose Rechenleistung. Quantencomputer unterscheiden sich nicht nur durch ihre Funktionsweise: Sie sind weder linear noch vorhersehbar, sondern multidimensional, da sich Elektronen bei der Quantenberechnung verschränken und überlagern und somit an vielen Orten gleichzeitig existieren können. Ein Quantencomputer kann unendlich viele Verbindun-

6
Segal (wie Anm. 3).

7
David L. Chandler, »Could the Universe Be a Giant Quantum Computer?«, in: Nature, 25.08.2023, https://www.nature.com/articles/d41586-023-02646-x.

gen parallel herstellen, und zwar mit einer Geschwindigkeit, zu der die menschliche Intelligenz nie in der Lage sein wird.

Diese technische Erklärung des Quantencomputers ist ein wichtiger Schritt, um Heaneys Werk auf einer anderen Ebene zugänglich zu machen. Aus konzeptueller Sicht bedeutet die Funktionsweise des Quantencomputers eine andere Vorstellung von Zeitlichkeit, die sich ausdehnt, entfaltet und multipliziert. Dies hat eine gewisse Ähnlichkeit mit der menschlichen Kultur, die sich ebenfalls in viele verschiedene und unerwartete Richtungen gleichzeitig bewegen kann. Die wenigsten Menschen möchten sich die Zukunft nur anhand vergangener Muster vorstellen: Während wir »die Bewegung der Geschichte als linear und kontinuierlich konzipieren, würden nur sehr wenige sagen, dass sie vorhersehbar ist«.[6] Man könnte sogar behaupten, Quantencomputing sei eine generative Form des Outputs, während die KI auf kumulativem Lernen beruht. Der Unterschied zwischen den Technologien lässt sich auch damit begründen, dass Quantencomputing nicht eine künstliche, sondern eine natürliche Form der Intelligenz ist – anders gesagt, dass »das Universum ein Quantencomputer ist«.[7]

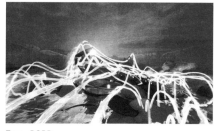

Ent-, 2022

In diesem Sinne hat die Quanteninformatik den Zauber einer anderen (gar göttlichen?) Welt. An dieses Gefühl der Andersweltlichkeit knüpft Heaneys Arbeit an. Sie macht die Quantenrealität sinnlich erfahrbar. Doch dazu muss sie den Gesetzen der klassischen newtonschen Physik folgen, muss die Komplexitäten von Quantensystemen in die Dimension der menschlichen Lebenswelt zurückübersetzen. Und so ist jedes Bild der Quantenwelt ein Versatzstück einer für uns unzugänglichen Realität und damit eine von vielen Interpretationen dieses Multiversums. Heaney bezieht sich häufig auf Umberto Ecos Das offene Kunstwerk (1962), in dem Eco die Pluralität von Quantenteilchen mit der Idee verbindet, ein Kunstwerk könne viele verschiedene Bedeutungen haben. Im Einklang mit dem Ethos des Quantendenkens ist auch Heaneys Werk für vielfältige Interpretationen offen. Dieser Ansatz zeigt sich in der Wahl ihrer Titel: Wie im Fall von Ent- (2022) bleiben diese oft unvollständig und damit offen für die Interpretationen der Betrachter*innen.

8
»Worldbuilding«,
Wikipedia-
Eintrag, https://
en.wikipedia.org/wiki/
Worldbuilding#cite_
note-15.

Heaneys Praxis zeigt nicht nur die binäre Natur der makroskopischen Realität auf, sondern deutet auch an, wie die Quantenwelt aussehen könnte, wenn sie für uns beobachtbar wäre. Die unendliche Verflechtung, die hier zum Vorschein kommt, kann vielleicht auch als Werkzeug dienen, um unsere nach newtonschen Gesetzen geordnete Realität besser verstehen zu lernen. Die Quantenrealität ist eine andere Welt, die eine neue Art des Sehens und Wahrnehmens ermöglicht, auch wenn sie unseren Sinnen größtenteils unzugänglich ist. Wie Lewis Carrolls Alice wird man auf eine erstaunliche Reise in eine alternative Welt entführt. Es mag wie Fiktion klingen, ist es aber nicht: Es ist Wissenschaft, und Heaneys Werk enträtselt die Zukunftsentwürfe der Science-Fiction.

Die Entformung der Welt

In der Fiktion kann man eine neue Welt entwerfen, von der Geografie über die Fauna und Sprache bis hin zur Technologie. Im Diskurs der bildenden Kunst, insbesondere an der Schnittstelle zu neuen Technologien, wird häufig der Begriff des »Worldbuilding« – die Konstruktion eines imaginären Universums – in Bezug auf Werke verwendet, die mit Spiel-Engines geschaffen werden. Auch Heaney verwendet sie, denn sie sind wichtige Werkzeuge in ihrem interdimensionalen Übersetzungsprozess von der Quantenrealität auf unsere newtonsche Erfahrungsebene. Die Etymologie des »Worldbuilding« steht auch im Zusammenhang mit der Physik, denn der Begriff erscheint erstmals in Arthur Eddingtons Raum, Zeit und Schwere. Ein Umriss der Allgemeinen Relativitätstheorie (1920), um »das Ausdenken hypothetischer Welten mit anderen physikalischen Gesetzen zu beschreiben«. [8] Heaney spricht jedoch lieber von »world un-shaping«, von Welt-Entformung, da dies besser zu den außergewöhnlichen Regeln der Quantenmechanik passe. Wenn die Eigenschaften eines Quantencomputers als atemporär, diskontinuierlich und expansiv beschrieben werden können, wie kann man damit beginnen, diese Realität aufzubauen? Sie lässt sich nicht in den bekannten Kontext und die Strukturen unserer erlebten Realität einbinden.

Im mehrdimensionalen Raum würde sich jedes Gebil-
de fast sofort wieder in der Masse auflösen (wie die
Formen in Heaneys Werk slimeCrawl). Stattdessen hat die
Quantenrealität mehrere dynamische Leben, Wege und Portale
auf verschiedenen Ebenen gleichzeitig.

Der Gedanke einer »Entformung der Welt« legt nahe, dass
es keine Welt mit klaren Grenzen gibt, der man eine fass-
bare Form geben könnte. Die Grenzen zwischen Konzepten wie
Online und Physisch, Realität und Fiktion werden aufgehoben.
Insbesondere löst sich die Infrastruktur, die unsere Wissens-
konstruktion bestimmt, unter dem Einfluss des quantenmecha-
nischen Denkens auf. In gewisser Weise ist der Quantencompu-
ter wie eine Blackbox: Ein System, das in Form von Inputs und
Outputs betrachtet werden kann, ohne dass man sein Innen-
leben kennt. Es überrascht daher nicht, dass Heaney bei der
Präsentation ihrer Arbeiten auf Blackbox-ähnliche Installatio-
nen zurückgreift, wie bei der bereits erwähnten 360-Grad-
Projektion Ent-. In diesem Werk – eine Interpretation der zen-
tralen Tafel von Hieronymus Boschs Der Garten der Lüste (um
1490–1510) – verwendet Heaney einen selbst geschriebenen
Quantencode, um ihre eigenen Aquarelle zu verzerren und zu
beleben. Das Ergebnis wird mithilfe einer Spiel-Engine zu-
sammengeführt und animiert. Es entsteht eine Sequenz von
überlagerten Bildern, die sich in einen umgestalteten, traum-
artigen Garten verwandeln, in den das Publikum eintaucht und
mit den Figuren aus dem Gemälde verschwimmt. Im Erleben
dieses Werks gibt es Momente, in denen man die (Quanten-
interpretation von) »Verschränkung« wahrnehmen kann: Kurze
Unschärfen in Bewegung oder ein plötzliches Aufblitzen. Auf
konzeptueller Ebene lassen sich Parallelen zwischen Boschs
Triptychon und der Quanteninformatik herstellen, da Techno-
logie als eine neue Religion betrachtet werden kann, die ein
Leben jenseits des Körpers verspricht.

Ich bin versucht, die Blackbox mit dem kunsthistorischen
Begriff des Tableau vivant (»lebendes Bild«) in Verbindung
zu bringen. Können immersive Installationen (zum Beispiel
VR oder 360°) als neue Formen von Tableaux vivants gelesen
werden? Diese Idee wird in der Kunsttheorie mehrfach aufge-
griffen; so untersuchte Jean-François Chevrier die Beziehung
zwischen Fotografie und Malerei und kam zum Schluss, dass
Fotografien, die Szenen aus der Kunstgeschichte inszenieren,

9
Sos Agaian und
Artyom Grigoryan,
»Brief Notes on the
Possibility of Copying
Cubits in Quantum
Systems«, in: WSEAS
Transactions on
Circuits and Systems,
21, 2022, S. 20–25,
https://wseas.com/
journals/cas/2022/
a045101-002(2022).
pdf.

auch Tableaux vivants schafften. Chevrier betont das Wechselspiel zwischen Realität und Fiktion sowie die Art und Weise, wie diese inszenierten Szenen traditionelle Vorstellungen über den Wahrheitsgehalt der Fotografie infrage stellen. So verstanden fordert ein Tableau vivant dazu auf, unsere Wahrnehmung von Realität, Darstellung und künstlerischer Tradition zu überdenken. Heaneys Kunst vermittelt ebenfalls eine skeptische Haltung gegenüber der Wahrheit, indem sie das traditionelle Verständnis von Realität hinterfragt und einen experimentellen Umgang mit konventionellen Kunstformen pflegt.

Im Anschluss an die Erkenntnisse der Quantenwissenschaften steht die Dekonstruktion von etablierten Realitäten und somit ein Prozess des Entformens und sogar des Verlernens im Zentrum Heaneys künstlerischer Praxis. Das Kopieren unbekannter Information ist im Rahmen der Quanteninformatik nicht möglich: Der Prozess, eine exakte Kopie von Informationen ohne Veränderung ihres ursprünglichen Zustands zu erstellen, wird als »Quantenklonen« bezeichnet und ist den Gesetzen der Quantenmechanik zufolge ausgeschlossen. [9] Etwas innerhalb der Quantenrealität zu erzeugen, bedeutet immer, etwas Neues zu schaffen, ohne das Vorhandene zu wiederholen oder zu kopieren. Im Gegensatz zu künstlicher Intelligenz braucht die Quanteninformatik die Vergangenheit nicht, um die Zukunft zu denken. Die Pädagogik des Verlernens, die im künstlerischen Diskurs verhandelt werden musste, ist dem Quantendenken bereits inhärent.

Traumschleier

Es gibt einiges über die Technologie der Bildfindung zu sagen. In Heaneys Fall ist die Zeichnung die Grundlage für viele ihrer Arbeiten, seien es VR-, Video- oder 3-D-Simulationen. Gleichzeitig stellt sich die Frage, wie sie Bilder erzeugen kann, die digitale Technologien nicht auch ohne die Quantenebene produzieren würden. Welche Ästhetik verkörpert die Pluralität der Quantenzustände?

Heaneys Aquarelle zeigen oft hybride Formen oder Kreaturen in verschiedenen Farben und bestehen aus

mehreren Bildschichten. Die Künstlerin erzählt, dass sie gleichzeitig mit der Aquarellmalerei und mit der Arbeit an Quantencomputern angefangen habe, und dass diese Praktiken Hand in Hand gingen. Der Zusammenhang entstand, weil sie herausfinden wollte, wie sich die Bearbeitung mithilfe eines Quantencomputers visuell auf ein Bild auswirken würde. Sie entschied sich für ein Aquarellbild, da »Wasser wie ein Quantenteilchen« sei, »wellenförmig«, es überflute das Blatt, breite sich aus und mische sich ein. Ich würde anfügen, dass die Entstehung eines Aquarells in seiner fließenden Unvorhersehbarkeit etwas Magisches hat. Dies trägt zu einer traumartigen Ästhetik bei, die in Heaneys Werken wiederholt vorkommt.

In ihrer Praxis experimentiert Heaney auch mit Schleim, wie in der Arbeit slimeCrawl (2023). Hier kombiniert sie Aufnahmen von Schleim und menschlichen sowie nichtmenschlichen Körpern, die sich auflösen und miteinander verschmelzen; es entstehen hybride Kreaturen und andere, vertraute Formen. Schleim erscheint auch in Heaneys Glas-, Skulptur- und Rauminstallationen sowie in ihren öffentlichen Vorträgen als anschauliche, sinnliche Metapher für die Quantenrealität. Als quellfähige, dehnbare und formbare Substanz gehört Schleim zu den nicht-newtonschen Fluiden, da er nicht dem newtonschen Gesetz des linear viskosen Fließverhaltens folgt.

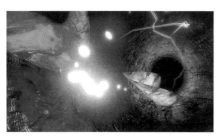

Heartbreak and Magic, 2024

In der Quantenphysik verändert der einfache Akt des Hinsehens den Zustand der Realität. Um auf die Wissenschaft dahinter zurückzukommen: Qubits reagieren sehr empfindlich auf Störfaktoren/Rauschen und Wechselwirkungen mit der Umgebung, die den Quantenzustand des Qubits stören können, wodurch es zerfällt. Trotz der begrenzten Wahrnehmungsmöglichkeiten von Quantenrealitäten bildet Heaney diese nach oder erschafft sie, indem sie sie durch einen Prozess der interdimensionalen Übersetzung erfahrbar macht. Während Quantenphänomene als künstlerisches Medium verwendet werden, betont dieser Übersetzungsprozess den Affekt, die Sinne und Emotionen sowie den performativen Charakter der Arbeit. Heartbreak and Magic (2024) ist ein emotionales VR-Erlebnis, das sich mit der persönlichen Trauer der Künstlerin auseinandersetzt. Es ist Ausdruck des Bedürfnisses nach alternativen Realitäten und sucht in der Quanten-

physik nach einem Verständnis von Leben und Tod.
Die traumartige Erfahrung beschwört die Magie einer
Anderswelt, um die Komplexität der Trauer zu bewältigen, das
Unbegreifliche fassbar zu machen und um herauszufinden, wie
die Quantenperspektive auch Empathie auslösen kann.

Ähnlich Alices fantastischer Reise taucht Heaneys Werk
in die sich ständig verändernden Sphären der Quanten-
informatik ein, wo Realitäten sich verschieben und verzweigen,
und wirft die Frage auf, ob der Quantencomputer eine quasi-
göttliche Rolle spielt. Heaneys Werk deutet an, dass unsere
Wahrnehmung der Wahrheit von Natur aus begrenzt ist und
dass das Quantendenken die Vorstellung einer unveränderli-
chen Realität infrage stellt. Vielleicht geht es aber auch darum,
dass unsere newtonsche Welt eine Illusion ist – ein einzelnes
Bild oder eine mögliche Interpretation eines viel größeren dy-
namischen Multiversums.

Heaneys Arbeit verkörpert eine Verschiebung der Auf-
merksamkeit rund um neue technologische Entwick-
lungen. Sie bietet nicht nur Reflexionspotenzial, sondern
auch einen Leitfaden, um unsere Welt anders zu träumen. Die
Quantenrealität erscheint schwer fassbar und dehnt sich in
alle Richtungen aus; vielleicht werden wir ihre Feinheiten nie
ganz begreifen können. Doch Heaneys Installationen, VR-, Ma-
lerei-, Schleim- und Glasarbeiten machen es möglich, einen
Blick durch den Quantenspiegel zu erhaschen. Heaneys Kunst
spricht die Sinne auf einer zutiefst emotionalen Ebene an, die
eine Erfahrung oder vielleicht nur den Hauch einer Erfahrung
einzufangen vermag, wie ein kleines Fenster in die unermessli-
chen Weiten der Quantenwelt. Als Pioniere im Diskurs über das
Verhältnis von Gesellschaft und Technologie können Künst-
ler*innen beeinflussen, wie neue Technologien wie der Quan-
tencomputer verstanden und eingesetzt werden. Und während
die Komplexität von Quantencomputern uns etwas Zeit ver-
schafft, erinnert die Erzählung von Alice daran, dass wir selbst
über unser Schicksal entscheiden und noch nicht vollständig
aus dem Traum erwacht sind. Es stellt sich also die Frage: Wie
geht es weiter, wenn wir noch im Traumschleier der gängigen
Illusion gefangen sind? Dies ist Libbys Wunderland.

Ariane Koek
QUANTUM STATES (OF MIND)

*T*he technology of quantum physics is still in its early ad-olescence. Yet the science behind it is taking hold of the artistic, popular, and cultural imagination at an unprecedented rate in the 2020s. From the rise of quantum psychotherapy and psychology and the Goethe Institut's new artists residencies program, Studio Quantum, to the opening of new institutions such as the Centre for Quantum and Society in the Netherlands, dedicated to quantum technologies for the good of humanity, we seem now to be existing in a quantum-obsessed world. Quantum has even become a word used to sell products and promote brands. And as a technology, it is said to be poised to change our world. For example, it has been predicted that quantum computing via molecular simulation may lead to the discovery of new materials as well as revolutionise healthcare and medicines. By the end of 2027, according to the research firm International Data Corporation (IDC), governments and businesses will invest some $16.4 billion in quantum computing alone. No wonder some have dubbed the twenty-first century the Quantum Age.

*S*o why is quantum physics, which started at the beginning of the twentieth century, now taking hold as a concept in society more than one hundred years later? How advanced is the technology that has developed from it? And how and why are artists drawn to these technologies, in particular quantum computing, and using them for their work?

*I*n their book *What is Philosophy?* the theorists Gilles Deleuze and Félix Guattari differentiate philosophy from

the arts and sciences. They define philosophy, famously, as the only activity that consists in forming and fabricating concepts, which are a form of endless becoming or coming-into-realization, giving it truly revolutionary power. The science of quantum physics challenges this exceptionalism directly, partly by its focus on the behaviour of the invisible world at at the molecular and atomic to subatomic level, which is beyond our human experience, scale, and representation, so it is firmly in the conceptual realm. Quantum physics can be defined as the theory describing the properties and behaviour of particles that make up atoms, and the energies and forces that shape matter and our visible reality. Its basic mathematical framework is known as quantum mechanics and was first developed in the 1920s by Niels Bohr, Werner Heisenberg, Erwin Schrödinger, and others.

*I*n the quantum mechanical world, created by the abstract language of mathematics, light and matter possess the same properties as both particles and waves. The observer and the apparatus become co-influencers on the outcome of any scientific experiments. Nothing is objective, fixed, or boundaried, or indeed even accurately measurable. [1] The Heisenberg principle, which brought uncertainty into science, is a core part of quantum mechanics and formalises openness and indeterminacy. This destroys the classical Newtonian view of an ordered, measurable world that operates in the linear way of cause and effect, binaries and opposition, beginning and ends.

*M*eeting the Universe Halfway: Quantum Physics and the Entanglement of Matter and Meaning by the physicist and philosopher Karen Barad clearly demonstrates how quantum physics is itself radically conceptual, discussing scientific concepts such as superposition, entanglement, and indeterminacy, which fundamentally challenge the way we look at and experience the world. [2] Everything is fluid and open to probability. Particles can co-exist in multiple states across time and space, a phenomenon otherwise known as superposition, or through entanglement, where particles can affect each other, too, changing the constitutional make-up of either one or both across time and space. Barad creates the neologism 'intra-action' to communicate the mutability and affective connectiveness of this quantum world, in which everything is in a state of constant becoming or 'mattering'. [3]

1
This is a reference to the so-called Measurement Problem in quantum mechanics, which in one interpretation can be defined as the phenomena in the quantum world in which a particle falls out of superposition when measurement is attempted.

2
In particular, see Karen Barad, *Meeting the Universe Halfway. Quantum Physics and the Entanglement of Matter and Meaning*, Durham, NC 2007.

3
Intra-action: things don't simply interact; they also fundamentally change each other's properties and existence by interacting. Hence the word intra-acting emphasising that the property itself not only acts upon others but is acted upon and changes.

4
Denise Ferreira da
Silva, *Unpayable Debt*
(London: Sternberg
Press, 2022).

*I*t is no wonder, then, that the Brazilian artist and philosopher Denise Ferrea da Silva calls for a 'quantum unlearning' to profoundly question reality and challenge the status quo of the present in order to de-colonise and de-imperialise our world in the future. [4] The art collective Black Quantum Futurism centres their socially driven practice on a radical artistic methodology inspired by quantum physics, combined with Afrofuturism and Afrodiaspora traditions of consciousness. They use this combination, for example, to challenge oppressive linear time constructs like clocks and maps, which promote Western white imperialist power structures. In fact, many concepts in quantum theories can be found, as BQF's work shows, in non-Western traditions and societies, and in far older wisdoms that predate Western science by thousands of years. For example, the Native American thinker and academic Leroy Little Bear, former director of native studies at Harvard, initiated a series of talks on this topic in 1992 at the Fetzer Institute, Michigan, USA with his friend, the physicist Daniel Bohm, famed colleague of Albert Einstein.

*A*nother reason why quantum physics has a more popular appeal, featuring in for example Academy Award-winning films such as *Everything Everywhere All at Once* (2022), is because it offers us an alternate reading of reality to the one in which we are living in the present. In the twenty-first century, we are confronted daily by increasing global insecurity, wars, inequality, poverty, and – above all – the climate emergency. Therefore it is comforting to be able to think that there are multiple co-existing realities, based on the many-worlds interpretation of quantum mechanics. The theory steps in where religion might normally be, offering a ghostly heaven-on-another-earth solution to the twenty-first century's seemingly endless millennial despair and angst, particularly when facing our rapidly accelerating sixth mass extinction event.

*E*qually, the idea of fluidity between particles and their intra-actions in the quantum world has a clear attraction particularly for queer and trans theory, social activism, and politics, because in quantum theory binaries are smashed, nothing is fixed, and everything is fluid. Artists are deeply drawn to these concepts, creating work that simulates the effect of quantum states, and often using quantum data to do so. For example, the Japanese electronic musician and visual

5
Gavin Parkinson,
Surrealism, Art and Modern Science (New Haven: Yale University Press, 2007). Also see his essay in Ariane Koek (ed.), *Entangle: Physics and the Artistic Imagination* (Berlin: Hatje Cantz, 2019)

artist, Ryoji Ikeda, has created artistic digital works, such as the audio-visual performance piece, *Superposition* (2012) and the immersive installations, *Supersymmetry* (2014) and *micro / macro* presented at ZKM (2015) which open up our eyes and ears to the proliferation of complex data which quantum physics and technologies give us unprecedented access to for increasing our understanding of the invisible workings of nature. The artist Refik Anadol runs machine learning

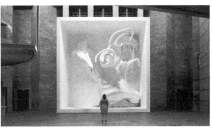

Refik Anadol, *Quantum Memories 2020*, National Gallery of Victoria, Melbourne, 2020, installation view, Courtesy of Refik Anadol Studio

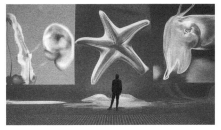

Entangled Others, *Decohering Delineation*, 2022–2023, Nxt Museum, Amsterdam, installation view

algorithms to process datasets that simulate quantum states, as in, for example, his work *Quantum Memories 2020*. This piece processes research data and algorithms drawn from more than 200 million images linked to nature from publicly available internet resources to create a visual effect of a quantum world. The Portugal based artist duo, Entangled Others, made *Decohering Delineation* their first piece with quantum computing by using its outputs to modify specially created software and neural networks. This generated a complex visual entanglement of natural and artificial beings as a critique of our granular classification of species, which separates and divides. However, there is nothing new about artists and writers, or the public for that matter, being fascinated by concepts of quantum physics and their revolutionary potential to disrupt our accepted notions of reality. This has happened since the theory was introduced at the beginning of the last century. In his pioneering work, the art historian Gavin Parkinson makes it very clear how artists such as Salvador Dali and Picasso, and the surrealist movement overall, were inspired by quantum physics.[5]

What is new today, however, is the emergence of quantum technologies, in particular quantum computing, which will eventually offer unprecedented information processing power and other potential we may not yet be able to conceive of, as the hardware evolves and develops. Quantum computers use qubits, or quantum bits of information, which can take a value of zero or one, but also can use a complex combination of zeros *and* ones at the same time, using the quantum physics of superposition and entanglements. If bits of information used by a traditional computer can be represented

6
In 1998, Isaac Chuang of the Los Alamos National Laboratory, Neil Gershenfeld of the Massachusetts Institute of Technology (MIT), and Mark Kubinec of the University of California at Berkeley created the first quantum computer (2-qubit) that could be loaded with data and output a solution. Although their system was coherent for only a few nanoseconds, it demonstrated the principles of quantum computation.

by a coin, then qubits are the equivalent of a sphere with data on multiple points of the sphere at the same time. In 1998, the first functioning quantum computer that could be loaded with data and output a solution ran on two qubits. [6] In principle, a quantum computer with 300 qubits can perform more calculations in an instant than there are atoms in the visible universe. Today, the big tech companies, such as IBM, Google, and Intel, are continuing to develop the hardware to handle quantum processing, but the hardware is still in its early phase of development. Many say it will take at least 5–10 years before quantum computing is fully scalable and fault-tolerant. At the moment, qubits are vulnerable to decoherence and therefore are not functioning to their fullest potential. In the far distant future, once these problems are solved, experts envision the quantum computer as a specialised chip, part of a conventional supercomputer accessed via the cloud. In contrast, other quantum technologies, such as quantum sensing and cryptography, are at a much higher level of development.

*F*ewer than a handful of artists, among them the British physicist and artist Libby Heaney and the Dutch pioneering net artist Joan Heemskerk, work directly with quantum computers today, interrogating their processing and hardware. They are able to go into much more depth by intentionally interfering in quantum processes and by producing genuine 'quantum effects' rather than by creating simulations through AI. For example, in her work *Q&Q*, Heemskerk investigates the decoherence of qubits – the transition from having genuine quantum effects like superposition and entanglement to digital indeterminacy. Libby Heaney has used IBM's publicly available quantum computers since 2019, writing her own code, using techniques she learned from her PhD thesis on entanglement to interfere with the processes and thus also create her own aesthetic. This scarcity of artists engaging with quantum computing itself results from the highly in-depth knowledge that is needed: Heaney has her PhD in quantum information theory, and Heemskerk has a very high level of technical expertise in information processing through collaborating closely with quantum scientists.

*T*hus, this far deeper level of quantum art is only very much in its infancy, due to the immense challenge of really understanding the hardware and quantum physics, together with

the substantial mind shift it requires. As the physi-
cist Richard Feynman once jokingly said, 'Anyone who
says they understand quantum physics, doesn't'. Libby Heaney
points to a future for quantum art that goes even further, en-
tangling the physically lived experience and the fictional one
in present time and space, when game engines are coupled
with quantum computing so that the viewer may experience
multiple, multi-sensory worlds from multiple perspectives si-
multaneously.

*I*n another way, art and technology will undergo an even
more fundamental shift. In his book, *The Work of Arts in
the Mechanical Age of Reproduction*, Walter Benjamin posited
that due to technology, the original in art is devalued and loses
its transcendent 'aura' because it can now be easily copied.
In the quantum age, when there are now an infinite number
of originals due to superposition and entanglement, we are
looking conversely at infinite universes of originals rather than
copies. This will certainly change our philosophical, and maybe
even financial, notion of value, based on originality.

*W*hat is clear is that quantum is the ultimate multiple
paradox. The clue is in the word. Quantum derives from
the Latin for amount or portion, which suggests a limit. It is
used to denote the science of the tiny, but is used in everyday
language to denote the enormous and infinite, as in the term
quantum leap. And it is even more complicated than that. As
the art historian James Elkin asks in a very complex argument in
his book, *Six Stories from the End of Representation*, how can
one even simulate visually quantum mechanics when nothing in
the science is what it seems and all appearances are deceptive,
including the phenomena that are so multi-dimensional and
intra-active? It is still outside our human consciousness, and
we will need a quantum shift in our minds to come anywhere
near it. Maybe because of this complexity we are on the verge –
thanks to quantum technologies, quantum theory, and artists
working deeply in the field – of reaching the real confluence
of art, science, and philosophy that Deleuze and Guattari pre-
dicted in *What is Philosophy?*

*I*n the meantime, there are deep societal concerns about
how quantum technologies will be used, who will control
and own them, how they will be applied, and how far they will

7
James Bridle, *New Dark Age. Technology and the End of the Future*, Verso, London, 2018, p. 2.

be used to strengthen rather than alleviate inequalities and the status quo in our world. Will they be used to exert more power and control rather than help create a new world order based on intra-relationships and fluidity of quantum theory, which far older wisdoms have always embraced? Equally it is unclear what the cost of quantum computing is to our energy systems and, most of all, to our depleting natural resources on Earth. For example, by 2050 many of the rare earth minerals that are fundamental parts of current computers and server farms will no longer exist, and yet they take up to millions of years to form. Before we get carried away by this quantum leap, we need to consider, among many other things, what portion of the earth will be destroyed and used to make these technologies happen. An equally important question: are we fully prepared for the quantum shift in our consciousnesses and the way we experience the world through quantum technologies?

*W*hat is clear is that as a society we urgently need to learn deeply about this technology. As the artist and theorist James Bridle puts it in his book the *New Dark Age: Technology or the End of the Future*, 'If we do not understand how complex technologies function, how systems of technologies interconnect, and how systems of systems interact, then we are powerless within them, and their potential is more easily captured by selfish elites and inhuman corporations...What is required is not understanding, but literacy'. [7]

Ariane Koek
QUANTEN-ZUSTÄNDE (DES BEWUSSTSEINS)

Die Quantentechnologie steckt noch in den Kinderschuhen. Doch die Wissenschaft dahinter, die Quantenphysik, erfasst in den 2020er-Jahren die künstlerische, populäre und kulturelle Imagination wie nie zuvor. Vom Aufkommen der Quantenpsychotherapie und -psychologie über das neue Residenzprogramm des Goethe-Instituts, Studio Quantum, bis hin zur Gründung neuer Institutionen wie dem Centre for Quantum and Society in den Niederlanden, das sich für den Einsatz von Quantentechnologien zum Wohle der Menschheit engagiert, scheinen wir heute in einer quantenbesessenen Welt zu leben. Das Wort »Quanten« wird sogar verwendet, um Produkte zu verkaufen und Marken zu bewerben. Denn die Quantentechnologie steht angeblich kurz davor, unsere Welt zu verändern. So wird spekuliert, ob Quantencomputing via Molekulardynamik-Simulation zur Entdeckung neuer Materialien beitragen und eine Revolution im Gesundheitswesen und in der Medizin bewirken könnte. Nach Angaben des Marktforschungsunternehmens International Data Corporation werden Regierungen und Unternehmen bis Ende 2027 rund 16,4 Milliarden Dollar allein in die Quantencomputertechnologie investieren. Kein Wunder, dass das 21. Jahrhundert auch als Quantenzeitalter bezeichnet wird.

Warum also setzt sich die Quantenphysik, deren Anfänge im frühen 20. Jahrhundert liegen, erst jetzt, über hundert Jahre später, im Bewusstsein der Gesellschaft durch?

Wie fortschrittlich ist die Technologie, die sich aus ihr entwickelt hat? Und wie und warum fühlen sich Künstler*innen zu diesen Technologien, insbesondere zum Quantencomputing, hingezogen und nutzen sie für ihre Arbeit?

In ihrem Buch Was ist Philosophie? grenzen die Theoretiker Gilles Deleuze und Félix Guattari die Philosophie von den Künsten und Wissenschaften ab. Sie definieren die Philosophie als die einzige Tätigkeit, die in der Erschaffung und Bildung von Begriffen besteht: Eine Form des endlosen Werdens oder der Hervorbringung, was ihr eine wahrhaft revolutionäre Kraft verleiht. Die Wissenschaft der Quantenphysik stellt diese Sonderstellung der Philosophie direkt infrage, denn auch sie ist in einer Welt der Konzepte zu verorten, die sie hervorbringt, um das Verhalten der unsichtbaren Welt auf molekularer und atomarer bis subatomarer Ebene zu beschreiben – eine Welt, die sich dem Maßstab der menschlichen Wahrnehmung und Darstellung entzieht. Die Theorie der Quantenphysik beschreibt die Eigenschaften und das Verhalten der Teilchen, aus denen Atome bestehen, sowie die Energien und Kräfte, die die Materie und die für uns sichtbare Realität formen. Ihr mathematisches Grundgerüst ist die Quantenmechanik, die in den 1920er-Jahren unter anderem von Niels Bohr, Werner Heisenberg und Erwin Schrödinger entwickelt wurde.

In der durch die abstrakte Sprache der Mathematik geschaffenen Welt der Quantenmechanik besitzen Licht und Materie die gleichen Eigenschaften wie Teilchen und Wellen. Die Beobachtung und der Messapparat beeinflussen das Ergebnis eines jeden wissenschaftlichen Experiments. Nichts ist objektiv, festgelegt und begrenzt oder auch nur genau messbar.[1] Die Heisenbergsche Unschärferelation, ein Kernstück der Quantenmechanik, bringt die Offenheit und Unbestimmtheit in die Wissenschaften ein und zerstört damit das von der newtonschen Physik geprägte Bild einer geordneten, messbaren Welt, die dem linearen Prinzip von Ursache und Wirkung, Binarität und Gegensatz, Anfang und Ende folgt.

Die Schriften von Karen Barad an der Schnittstelle von Physik und Philosophie zeigen deutlich, dass die Quantenphysik selbst radikal konzeptuell ist. Barad erörtert, wie wissenschaftliche Begriffe wie Überlagerung, Verschränkung und Unschärfe die Art und Weise, wie wir die Welt betrachten

2
Siehe insbesondere Karen Barad, Meeting the Universe Halfway. Quantum Physics and the Entanglement of Matter and Meaning, Durham, NC 2007. Eine Auswahl von Barads Schriften ist in deutscher Übersetzung erschienen, siehe: Karen Barad, Verschränkungen, aus dem Englischen von Jennifer Sophia Theodor, Berlin 2015.

3
»Intra-Aktion«: Die Dinge interagieren nicht nur, sondern sie verändern durch ihre Interaktion auch grundlegend ihre Eigenschaften und ihre Existenz. Daher das Wort »intra-agierend«, das diese Wechselwirkung betont – Eigenschaften sind beidseitigen Einwirkungen und Veränderungen ausgesetzt.

4
Denise Ferreira da Silva, Unpayable Debt, London 2022.

und erleben, grundlegend infrage stellen.[2] Folgen wir den Konzepten der Quantenphysik, ist alles fließend und mutmaßlich. Teilchen können in mehreren Zuständen über Zeit und Raum hinweg koexistieren: Das wird Überlagerung oder auch Superposition genannt. In der Verschränkung kommt hinzu, dass sich Teilchen gegenseitig beeinflussen können, so verändern sich die Beschaffenheit eines oder beider Teilchen über Zeit und Raum hinweg. Barad hat den Neologismus »Intra-Aktion« geschaffen, um die stetige Veränderlichkeit und die affektive Verbundenheit der Quantenwelt zu vermitteln, in der sich alles in einem Prozess des ständigen Werdens befindet.[3]

Kein Wunder also, dass die brasilianische Künstlerin und Philosophin Denise Ferreira da Silva zu einem »Quantenverlernen« aufruft. Dieser Prozess soll die Realität grundlegend hinterfragen und den Status quo der Gegenwart zur Debatte stellen, um zur zukünftigen Entkolonialisierung und Entimperialisierung unserer Welt beizutragen.[4] Die sozial orientierte Praxis des Kunstkollektivs Black Quantum Futurism (BQF) verbindet eine radikale, von der Quantenphysik inspirierte künstlerische Methodik mit dem Afrofuturismus und den Bewusstseinstraditionen der Afrodiaspora. Das BQF-Kollektiv nutzt diese Kombination, um zum Beispiel unterdrückerische lineare Zeitkonstrukte wie Uhren und Landkarten infrage zu stellen, die westliche, weiße und imperialistische Machtstrukturen fördern. Tatsächlich finden sich, wie die Arbeit des BQF zeigt, viele Konzepte der Quantentheorie in nicht-westlichen Traditionen und Gesellschaften und in weitaus älteren Wissenskulturen wieder, die der westlichen Wissenschaft um Tausende von Jahren vorausgehen. So initiierte der indigene nordamerikanische Denker und Wissenschaftler Leroy Little Bear, Gründungsdirektor der Native Studies in Harvard, 1992 am Fetzer Institute in Michigan eine Reihe von Gesprächen zu diesem Thema mit dem Physiker Daniel Bohm, einem einstigen Kollegen Einsteins.

Die Quantenphysik übt heute auch eine größere Anziehungskraft aus und wird beispielsweise in Oscar-prämierten Filmen wie Everything Everywhere All at Once (2022) thematisiert, da sie uns eine alternative Deutung unserer heutigen Realität bietet. Im 21. Jahrhundert sind wir täglich mit zunehmender globaler Unsicherheit, mit Kriegen, Ungleichheit, Armut und vor allem mit dem Klimanotstand konfrontiert. Die

Vorstellung mehrerer parallel existierender Realitäten, wie es die Viele-Welten-Interpretation der Quantenmechanik behauptet, wirkt daher tröstlich. Die Quantentheorie tritt an die Stelle der Religion und bietet eine geisterhafte, »Himmel-auf-einer-anderen-Erde«-Erlösung von der scheinbar endlosen Verzweiflung und Angst des 21. Jahrhunderts, insbesondere angesichts des sich rasch beschleunigenden sechsten Massensterbens.

Auch die Idee der Fluidität und der Wechselwirkung zwischen Teilchen in der Quantenwelt wirkt anziehend, insbesondere für die Queer- und Trans-Theorie und den sozialen und politischen Aktivismus dieser Bewegung. Denn in der Quantentheorie werden Binaritäten zerschlagen, nichts ist festgelegt und alles ist fließend. Künstlerinnen und Künstler fühlen sich von diesen Konzepten stark angezogen und schaffen Werke, die die Wirkung von Quantenzuständen simulieren und dazu auch Quantendaten verwenden. Der japanische Elektronikmusiker und bildende Künstler Ryoji Ikeda beispielsweise schafft digitale Kunstwerke wie die audiovisuelle Performance Superposition (2012) und die immersiven Installationen Supersymmetry (2014) und micro \ macro, die 2015 im ZKM präsentiert wurden. Diese Arbeiten öffnen unsere Augen und Ohren für die Menge und Vielfalt an komplexen Daten, zu denen uns die Quantentechnologie einen noch nie dagewesenen Zugang bietet, und sie erweitern damit unser Verständnis für die unsichtbaren Vorgänge der Natur. Der Künstler Refik Anadol nutzt maschinell lernende Algorithmen, um Datensätze zu verarbeiten, die Quantenzustände simulieren. Sein Werk Quantum Memories (2020) verarbeitet Forschungsdaten und Algorithmen basierend auf mehr als 200 Millionen Bildern von Naturphänomenen aus öffentlich zugänglichen Internetressourcen, um den visuellen Effekt einer Quantenwelt zu erzeugen. Das in Portugal ansässige Künstlerduo Entangled Others hat mit Decohering Delineation sein erstes Werk mit Quantencomputing geschaffen: Sie nutzten seine Outputs, um speziell dafür entwickelte Software und neuronale Netze zu modifizieren. So entsteht eine komplexe visuelle Verschrän-

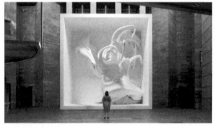

Refik Anadol, Quantum Memories 2020, National Gallery of Victoria, Melbourne, 2020, Ausstellungsansicht, Courtesy of Refik Anadol Studio

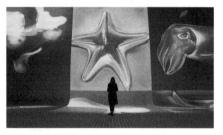

Entangled Others, Decohering Delineation, 2022–2023, Nxt Museum, Amsterdam, Ausstellungsansicht

5
Gavin Parkinson,
Surrealism, Art and
Modern Science, New
Haven 2007. Siehe
auch seinen Essay in
Ariane Koek (Hrsg.),
Entangle: Physics and
the Artistic Imagina-
tion, Berlin 2019.

6
1998 schufen
Isaac Chuang vom
Los Alamos National
Laboratory,
Neil Gershenfeld
vom Massachusetts
Institute of Techno-
logy (MIT) und Mark
Kubinec von der Uni-
versity of California in
Berkeley den ersten
Quantencomputer
(2-Qubit). Obwohl
ihr System nur wenige
Nanosekunden
lang kohärent war,
demonstrierte es
die Grundsätze der
Quantenberechnung.

kung von natürlichen und künstlichen Wesen, eine Kri-
tik an unserer groben Klassifizierung der Arten, die auf
Trennung und Spaltung ausgerichtet ist. Die Faszination der
Quantenmechanik mit ihrem revolutionären Potenzial, unsere
tradierten Vorstellungen von Realität auf den Kopf zu stellen –
insbesondere für Künstler*innen und Schriftsteller*innen – ist
jedoch nichts Neues. Sie ist so alt wie die Theorie selbst, die zu
Beginn des letzten Jahrhunderts entstand. Der Kunsthistoriker
Gavin Parkinson etwa zeigt in seinem bahnbrechenden Werk
über den Surrealismus und die Wissenschaften auf, wie Dalí
und Picasso wie auch die surrealistische Bewegung insgesamt
von der Quantenphysik inspiriert waren.[5]

Neu ist jedoch das Aufkommen der Quantentechnologien,
insbesondere der Quantencomputer, die mit Weiterent-
wicklung der Hardware irgendwann eine noch nie dagewesene
Verarbeitungsleistung bieten werden, sowie andere Möglich-
keiten, die wir uns vielleicht noch gar nicht vorstellen können.
Quantencomputer verwenden Qubits: Quanteninformations-
einheiten, die wie klassische Bits den Wert 0 oder 1 annehmen
können, aber auch eine komplexe Kombination von Nullen und
Einsen gleichzeitig, indem sie sich die quantenmechanischen
Zustände der Überlagerung und Verschränkung zunutze ma-
chen. Können wir die Informationseinheiten eines herkömm-
lichen Computers mit einer Münze darstellen, so entsprechen
Qubits einer Kugel mit Daten an mehreren Punkten der Kugel
gleichzeitig. 1998 lief der erste funktionierende Quantencom-
puter, der mit Daten geladen werden konnte und Lösungen
ausgab, mit 2 Qubits.[6] Im Prinzip könnte ein Quantencomputer
mit 300 Qubits in einem einzigen Moment mehr Berechnungen
durchführen, als es Atome im sichtbaren Universum gibt. Heute
arbeiten die großen Technologieunternehmen wie IBM, Google
und Intel an der Entwicklung von Hardware für die Quanten-
verarbeitung, doch sie befindet sich noch in einer sehr frühen
Entwicklungsphase. Voraussichtlich wird es noch mindestens
fünf bis zehn Jahre dauern, bis das Quantencomputing voll-
ständig skalierbar und fehlertolerant ist. Derzeit sind Qubits
anfällig für Dekohärenz: Quantenmechanische Zustände wie
die Überlagerung werden nicht lange genug ungestört auf-
rechterhalten, und die Quantencomputer können daher nicht
ihr volles Potenzial entfalten. In ferner Zukunft, wenn diese
Probleme gelöst sind, stellen sich Expert*innen den Quanten-
computer als spezialisierten Chip vor, als Teil eines herkömm-

lichen Supercomputers, auf den über die Cloud zu-
gegriffen wird. Andere Quantentechnologien wie die
Quantensensorik und die Kryptografie befinden sich dagegen
auf einem wesentlich höheren Entwicklungsstand.

Nur eine Handvoll Künstler*innen, darunter die britische
Physikerin und Künstlerin Libby Heaney und die nie-
derländische Netzkünstlerin Joan Heemskerk, arbeiten heute
direkt mit Quantencomputern und erproben ihre Verarbei-
tungsleistung und Hardware. Ihre Auseinandersetzung mit dem
Thema geht in die Tiefe, denn sie greifen intentional in Quan-
tenprozesse ein und erzeugen echte »Quanteneffekte«, anstatt
diese mittels KI zu simulieren. In ihrer Arbeit Q&Q untersucht
Heemskerk zum Beispiel die Dekohärenz von Qubits – den
Übergang von echten quantenmechanischen Zuständen wie
Überlagerung und Verschränkung zur digitalen Unbestimmt-
heit. Libby Heaney nutzt seit 2019 die öffentlich zugänglichen
Quantencomputer von IBM, schreibt ihren eigenen Code und
nutzt Techniken, die sie sich im Rahmen ihrer Dissertation über
Verschränkung aneignete, um in die Prozesse einzugreifen und
so auch ihre eigene Ästhetik zu schaffen. Die Tatsache, dass
nur wenige Künstler*innen mit Quantencomputern arbeiten, ist
eine Konsequenz des dafür notwendigen, sehr tiefgreifenden
Wissens: Heaney hat in Quanteninformationstheorie promo-
viert, und Heemskerk verfügt aufgrund ihrer engen Zusammen-
arbeit mit Quantenwissenschaftler*innen über ein hohes Maß
an technischem Know-how in der Informationsverarbeitung.

Diese tiefere Ebene der Quantenkunst befindet sich also
noch am Anfang ihres Entwicklungsprozesses. Einerseits,
weil es eine immense Herausforderung ist, die Quantenphysik
und die Hardware wirklich zu verstehen, andererseits, weil die-
ser Ansatz einen erheblichen Bewusstseinswandel erfordert.
Denn die Quantenphysik ist notorisch komplex; so bemerkte
der Physiker Richard Feynman einmal scherzhaft: »Wer behaup-
tet, die Quantenphysik verstanden zu haben, hat sie nicht ver-
standen.« Libby Heaneys Werk verweist auf eine Zukunft der
Quantenkunst, die auf der konzeptuellen Ebene noch weiter
geht, indem sie eine Verschränkung des körperlichen Erlebens
und der fiktiven Vorstellung der Quantenwelt in Raum und Zeit
erzeugt. Mit Quantencomputern gekoppelte Spiel-Engines er-
möglichen es den Betrachter*innen, mehrere multisensorische
Welten aus mehreren Perspektiven gleichzeitig zu erleben.

Das Verhältnis von Kunst und Technologie wird in einer anderen Hinsicht eine noch grundlegendere Veränderung erfahren. In seinem Essay Das Kunstwerk im Zeitalter seiner technischen Reproduzierbarkeit (1936) postulierte Walter Benjamin, dass die Technologie das Original in der Kunst entwerte: Da es nun leicht kopiert werden könne, verliere es seine transzendente »Aura«. Im Quantenzeitalter, in dem es aufgrund von Überlagerung und Verschränkung eine unendliche Anzahl von Originalen gibt, haben wir es umgekehrt mit unendlichen Universen von Originalen statt Kopien zu tun. Dies verändert unsere philosophischen und vielleicht sogar finanziellen Wertvorstellungen, die auf Originalität beruhen.

Die Quantenphysik ist das ultimative mehrfache Paradoxon. Der Hinweis liegt im Wort selbst: Der Begriff »Quanten« leitet sich vom lateinischen Wort für Menge oder Anteil ab, was auf eine Grenze hindeutet. Es bezeichnet die Wissenschaft des Winzigen; in der Alltagssprache hingegen erscheint es als Bezeichnung für das Enorme und Unendliche, wie im Begriff »Quantensprung«. Und es ist sogar noch komplizierter. So fragt der Kunsthistoriker James Elkin in seinem Buch Six Stories from the End of Representation: Wie kann man die Quantenmechanik überhaupt visuell simulieren, wenn nichts in dieser Wissenschaft so ist, wie es scheint, und alle Erscheinungen trügerisch sind, einschließlich der für uns so faszinierenden multidimensionalen und »intra-aktiven« Phänomene? Die Quantenmechanik liegt immer noch außerhalb unseres menschlichen Bewusstseins, und wir werden eine Quantenverschiebung in unserem Denken brauchen, um ihr auch nur nahe zu kommen. Vielleicht stehen wir aufgrund dieser Komplexität kurz davor – dank der Quantentechnologien, der Quantentheorie und der Künstler*innen, die sich so intensiv mit diesem Thema befassen –, die effektive Verschmelzung von Kunst, Wissenschaft und Philosophie zu erreichen, die Deleuze und Guattari in Was ist Philosophie? voraussagten.

In der Zwischenzeit gibt es tiefgreifende gesellschaftliche Bedenken darüber, wie die Quantentechnologien in der Zukunft eingesetzt und angewendet werden, wer sie kontrollieren und besitzen wird, und inwieweit sie verwendet werden, um die Ungleichheiten und den Status quo unserer Welt zu verstärken, anstatt eine Verbesserung dieser Zustände anzustreben. Wird diese Technologie die Ausübung von Macht und

7
James Bridle,
New Dark Age.
Der Sieg der Techno-
logie und das Ende
der Zukunft, aus
dem Englischen von
Andreas Wirthensohn,
München 2020, S.11.

Kontrolle befördern, oder kann sie zur Schaffung einer neuen Weltordnung beitragen, die auf der Wechselwirkung von Beziehungen und der Fluidität der Quantentheorie beruht, wie sie weitaus ältere Weisheiten schon erkannt haben?

Ebenso unklar ist, welche Kosten das Quantencomputing für unsere Energiesysteme und vor allem für unsere schwindenden natürlichen Ressourcen mit sich bringt. So wird es beispielsweise bis 2050 viele Metalle der seltenen Erden, die für die heutigen Computer und Serverfarmen von grundlegender Bedeutung sind, nicht mehr geben, ihre Entstehung dauert jedoch Millionen von Jahren. Bevor wir uns von diesem Quantensprung mitreißen lassen, sollten wir unter anderem bedenken, welcher Anteil der Erde ausgenutzt und zerstört wird, um diese Technologien zu ermöglichen. Eine ebenso wichtige Frage: Sind wir auf die Quantenverschiebung in unserem Bewusstsein und in unserer Erfahrung der Welt, die diese Technologie auslösen wird, wirklich vorbereitet?

Klar ist, dass wir als Gesellschaft dringend mehr über diese Technologie lernen müssen. Wie der Künstler und Theoretiker James Bridle in seinem Buch New Dark Age. Der Sieg der Technologie und das Ende der Zukunft schreibt: »Wenn wir nicht verstehen, wie komplexe Technologien funktionieren, wie Technologiesysteme miteinander vernetzt sind und wie Systeme von Systemen interagieren, sind wir innerhalb dieser Systeme machtlos, und egoistische Eliten und unmenschliche Unternehmen können sich ihres Potenzials umso leichter bemächtigen. [...] Was wir brauchen, ist nicht Verständnis, sondern Bildung.«[7]

Paul Luckraft and Julia Greenway
LIBBY HEANEY, SLIMEQRAWL

You are now quantum, a packet of pure energy, coupled with the flirty fluctuations of a zero point, the void.
Libby Heaney, *slimeQore* performance, 2022

Seductively spinning golden looms, cascading black tar-like substances, lips smeared in blue and green pigments mouthing silent words, all increasingly subsumed and merged beneath gauzy membranes of rippling snail flesh and mucus. What is *slimeQrawl* saying?

A pioneering voice at the intersection of art and quantum physics, multimedia artist Libby Heaney makes visible, audible, and tangible the strange qualities and significant real-world implications of quantum computing. Building from her PhD and background of extensive professional research into theoretical quantum information science, Heaney creates moving-image installations, performances, and sculptural works that investigate the contested ecological, political, and social implications of an entirely new technological realm.

What do we mean by 'quantum', and what are the specific aspects that Heaney responds to and works with? In short, and paraphrasing from Heaney's many insightful expositions on the topic, quantum computers process information using the laws of quantum physics rather than the laws of Newtonian physics that underpin our digital infrastructure.

1
Adina Glickstein,
"Multiple Matters:
An Interview with
Libby Heaney",
Spike art magazine
(April 19, 2022),
https://www.
spikeartmagazine.
com/?q=articles/
multiple-matters-
interview-Libby-
Heaney. Accessed
February 8, 2024.

Digital computation is based on the binary system of 0 and 1, where units of information (bits) can only exist in either of the binary states. It's this fixed ontology that Heaney argues has led to a mechanical, limited way of perceiving the world. In quantum computing, however, a quantum-bit (or qubit) can exist in both 0 and 1 simultaneously, enabling objects to do multiple tasks at once. This parallel, multidimensional quality is what gives quantum computers such a huge advantage in processing speed over purely linear digital computers. A problem that might take hundreds of years to solve on a digital supercomputer might only take a few hours on a quantum one. [1]

*I*t's important to note that full-scale quantum computers don't yet exist. However, governments and Big Tech companies are at this moment engaged in a furious dash to be the first to develop them, involving huge financial investment. Harnessed and used positively, quantum computing might allow problem-solving at a scale that could unlock seemingly intractable problems, such as the production of clean energy at a volume large enough to replace fossil fuels. While acknowledging this potential, Heaney is keen to point out the – sadly more likely – misuse of newly wielded power. History has shown that industrial capitalism uses new tools to extract: harder, faster, stronger.

slimeQrawl, 2023 (detail)

*A*n exponential acceleration in processing speed is not the core attraction for Heaney in centring her artistic experiments around quantum. Instead, it is the implication of a new paradigm of non-binary superposition and entanglement, whereby particles in the extreme cold inside a quantum computer exist in multiple states or places at once (this concept may be recognizable from the many-worlds interpretation of quantum physics found in popular culture, such as 2022's Oscar-winning movie *Everything Everywhere All at Once*) or join together in wavelike ways that are hard to verbalise or visualise. One metaphor for such entanglement and quantum 'particles', where no boundary exists between inside and outside, is a constant flow of a porous liquid. Heaney has speculatively imagined and categorised this as 'slime'. Here she draws on the negative associations of the word in relation to

2
James Bridle, *Non-Binary Machines, Ways of Being: Beyond Human Intelligence* (London: Penguin Random House, 2022), 191–194.

manipulative human behaviour (hello again, Big Tech) and the common human sense of disgust at the interior, mucky aspects of our own bodies. Crucially, however, such negativity is subverted with a celebration of slime as an agent that dissolves the borders between individual and collective agency and between the human and other species.

Slime recurs throughout Heaney's recent practice as a palpable metaphor for the theory of entanglement. It took the form of a physical material for the audience to touch in the spoken-word and video performance *slimeQore* (2022); as a green computer-generated image spilling over a rendered quantum computer in a number of her film works; as glossy glass forms slipping off the end of pedestals and ledges and around pipes in a series of sculptures from 2022; and layered through quantum video processes to a state of abstraction in *slimeQrawl* (2023), an immersive installation commissioned by Shoreditch Arts Club, London.

Slime is a swelling, flexing, breathing mucus. It is a remnant of the natural world, and through its tactile qualities it points to systems of intelligence embedded within it. Classical entanglement exists all around us: in the mycelia of fungi that form a network underneath the forest floor, sending messages between trees; in the unique migratory patterns of birds; and in the fact that some slime moulds can solve spatial efficiency problems more readily than computers.[2] The poetic intersection between digital and natural networks is encapsulated through these systems. Almost beyond our ability to comprehend, they are prompts to actively look outside ourselves to the complexity that is all around us. Accepting and understanding the multiple entities converging and co-operating creates a new methodology of thinking, living, and being. As a different ontological category entirely, quantum entanglement takes this further. If slime mould behaved in a quantum fashion, it would exist in all possible spatial configurations – expanding, contracting, branching left, branching right – at the same time. These would be layered over each other in a type of multiverse, a phenomenon hinted at in the multiple layers of video in *slimeQrawl*.

Heaney intuitively connects to her audience using slime as the embodiment of quantum. Recently she invited

audience members to an interactive immersive gaming environment titled *Ent- (Many Path Version)* (2022) held at Gazelli Art House, London, which was navigated by an Xbox controller that rested patiently on a slimly monstrous sculpture between players. Prior to this, she has placed slime directly into the hands of audiences. Commissioned by the Zabludowicz Collection in 2022 as part of the program of events accompanying the exhibition *Among the Machines*, the piece *slimeQore* (2022) was an immersive video montage and a live performance. It involved the projection of images over the top of the installed exhibition, like a layer of new material oozing in from the roof of the gallery space. The image-editing process used in the making of the video was a precursor to that used in the new *slimeQrawl* video, harnessing IBM's five-qubit quantum computing power to produce shimmering layers of imagery, as the wavelike peaks and troughs of quantum superposition and entanglement reveal different aspects of the source's video clips.

*H*eaney aimed to erode the barrier between performer and viewer: to do this, she distributed to the audience small black boxes containing the slime she had made; then, in a spoken text she delivered live while seated on a stage, the artist encouraged the audience to open the boxes and play with the material at designated points, making tactile (and absurdist) some of the qualities of quantum explored in the performance. Taking influence from quantum-physicist-turned-feminist-theorist Karen Barad, Heaney used word play to extrapolate the many possible connotations of a sticky, messy materiality that destabilises the divisions between entities. Heaney references Barad's theory that humans and non-humans emerge through material and tactile relationships, stating: 'The quantum theory of touching is radically different from the classical explanation. Actually, it is radically queer. Is touching not by its very nature always an involution, invitation, invisitation, wanted or unwanted of the stranger within? A quantum queering of identity'. [3] Heaney's use of the term 'queer' when framing her work builds on Barad's notion of the radically uncontainable, emphasizing the sense of a fundamental unsettling of perceived hierarchies of order, extending the connotations of the word queer beyond human sexuality or gender identity.

*T*he multiplicity of images and meanings contained in Heaney's practice can be sensed, reacted to, and manipulated by the audience. Through a process of abstraction, slime embodies the tangible materiality of the quantum world. It suggests inherently corporeal qualities: wet, sexy, and feminine. *slimeCrawl* portrays slime encasing painted lips and being squeezed through the fingers of a manicured hand. Combined, these elements evoke the sensation of ASMR (autonomous sensory meridian response) videos on the Internet, where voices whisper soothingly through social media feeds while demonstrating make-up application or gently squeezing slime. This experience provides a calming, sexualized feeling, transporting its algorithmically fed viewer to an altered state. It's important to note that the dislocated body parts in the video belong to Heaney, who in this instance places herself inside the video rather than as a presence reading a scripted narration over the top of images. Images of these body parts are interwoven with images of other species, specifically close-up shots of the writhing bodies of gastropods: *slimeCrawl* is overtly feminine in its origin but is visually queered through the vastness and unknowability of quantum space.

*A*lthough complex in their construction, Heaney's works are not exclusively technical or instructional in emphasis. Instead, they are characterised by their tactility, and the artist's desire to explore the possible intersections of quantum with the contemporary structures of gender, sex, identity, and class. In her immersive world-building practice, Heaney represents phenomena such as entanglement and non-binary states by the playful manipulation of language, narrative constructions, and metaphors, such as liquidity and slime. A multivalent critical practice, Heaney's approach utilises quantum as a tool and a medium with which to question the structures we accept as our reality, and to suggestively hint at the interconnectedness of everything in our known or unknown world.

Paul Luckraft und Julia Greenway
LIBBY HEANEY, SLIMEQRAWL

Jetzt bist du ein Quantum, ein Päckchen reiner Energie, verbunden mit den verspielten Schwankungen einer Nullstelle, der Leere.

Libby Heaney, slimeQore performance, 2022

Verführerisch kreisende goldene Webrahmen, kaskadenartig herabfallende schwarze teerähnliche Substanzen, mit blauen und grünen Pigmenten beschmierte Lippen, die lautlos Worte bilden: All das verschwimmt zunehmend, wird überlagert von hauchdünnen Membranen aus wogendem Schleim und Schneckenleibern. Was will uns slimeQrawl sagen?

Als Pionierin an der Schnittstelle von Kunst und Quantenphysik macht die Multimediakünstlerin Libby Heaney die seltsamen Eigenschaften und realen Auswirkungen von Quantencomputern auf unsere Welt sichtbar, hörbar und spürbar. Aufbauend auf ihrer Promotion und umfangreichen Forschung auf dem Gebiet der theoretischen Quanteninformation schafft Heaney Bewegtbild-Installationen, Performances und Skulpturen, die die umstrittenen ökologischen, politischen und sozialen Auswirkungen einer ganz neuen technologischen Sphäre untersuchen.

Was versteht man unter »Quanteninformation« und welche spezifischen Aspekte davon greift Heaney auf? Kurz gesagt (und in Anlehnung an die aufschlussreichen Aus-

1
Adina Glickstein,
»Multiple Matters:
An Interview with
Libby Heaney«, in:
Spike Art Magazine,
19. April 2022,
https://www.
spikeartmagazine.
com/?q=articles/
multiple-matters-
interview-Libby-
Heaney.

führungen der Künstlerin) verarbeiten Quantencomputer Informationen nach den Gesetzen der Quantenphysik statt nach den Gesetzen der newtonschen Physik, die unserer digitalen Infrastruktur zugrunde liegen. Digitale Berechnung basiert auf dem binären System von 0 und 1, wobei Informationseinheiten (Bits) nur jeweils in einem dieser binären Zustände existieren können. Diese starre Ontologie hat laut Heaney zu einer mechanischen, begrenzten Wahrnehmung der Welt geführt. Im Quantencomputing hingegen kann ein Quantenbit (oder Qubit) gleichzeitig in den Zuständen 0 und 1 existieren. Diese Überlagerung ermöglicht es, dass Objekte (wie zum Beispiel Computerprogramme) mehrere Aufgaben gleichzeitig erfüllen. Diese parallele, multidimensionale Eigenschaft verschafft Quantencomputern einen enormen Vorteil bei der Verarbeitungsgeschwindigkeit gegenüber rein linearen Digitalcomputern. Für ein Problem, dessen Lösung auf einem digitalen Supercomputer Hunderte von Jahren dauern könnte, braucht ein Quantencomputer unter Umständen nur wenige Stunden.[1]

slimeQrawl, 2023 (Detail)

Es ist wichtig festzuhalten, dass vollwertige Quantencomputer noch nicht existieren. Allerdings liefern sich Regierungen und die Big-Tech-Konzerne derzeit unter Einsatz enormer finanzieller Investitionen einen Wettlauf, um als erste einen solchen zu entwickeln. Positiv genutzt könnte die Quanteninformation Lösungen in einem bisher unbekannten Ausmaß erschließen und somit neue Ansätze für scheinbar festgefahrene Problematiken entwickeln – wie etwa die Produktion einer ausreichenden Menge an sauberen Energien, um fossile Brennstoffe zu ersetzen. Heaney erkennt dieses Potenzial an, weist aber auch auf den – leider wahrscheinlichen – Missbrauch dieser neu gewonnenen Macht hin. Ein Blick in die Geschichte zeigt, dass der industrielle Kapitalismus neue Technologien zur Extraktion einsetzt, nach dem Prinzip: härter, schneller, stärker.

Es ist nicht die Verheißung einer exponentiellen Beschleunigung der Datenverarbeitung, die Heaney dazu bewegt, ihre künstlerischen Experimente auf die Quantenwelt zu fokussieren. Vielmehr geht es ihr um das Bedeutungspotenzial eines neuen Paradigmas non-binärer Zustände, ausgehend

von den quantenmechanischen Phänomenen der Verschränkung und der Überlagerung (auch Superposition genannt). In der extremen Kälte im Inneren eines Quantencomputers können Teilchen in mehrfachen Zuständen oder Positionen gleichzeitig existieren – ein Konzept, das in der Popkultur verbreitet ist, besonders in Form der Viele-Welten-Interpretation der Quantenphysik, wie etwa im Oscar-prämierten Film *Everything Everywhere All at Once* (2022). Teilchen gehen untereinander auch wellenartige Verbindungen ein, die schwer zu beschreiben oder zu visualisieren sind. Ein treffendes Bild für solche Verschränkungen und für »Teilchen«, wo aber keine Grenze zwischen innen und außen vorhanden ist, ist der konstante Strom einer porösen Flüssigkeit. Heaney hat sich dies spekulativ als »Schleim« vorgestellt und dementsprechend eingeordnet. Dabei bezieht sie sich auf die negativen Assoziationen dieses Begriffs im Zusammenhang mit manipulativem menschlichen Verhalten (Big Tech lässt grüßen) sowie auf den weitverbreiteten Ekel der Menschen gegenüber dem klebrig-schmutzigen Innenleben unserer eigenen Körper. Entscheidend ist jedoch der subversive Umgang mit dieser Negativität: Heaney feiert den Schleim als Mittel, um die Grenzen zwischen individuellem und kollektivem Handeln sowie zwischen Menschen und anderen Spezies aufzulösen.

Schleim taucht in Heaneys künstlerischer Praxis der letzten Jahre wiederholt als anschauliche Metapher für die Theorie der Quantenverschränkung auf: Als physisches Material zum Anfassen für das Publikum der Spoken-Word- und Video-Performance *SlimeCore* (2022); als grünes computergeneriertes Bild, das in mehreren ihrer Filmarbeiten über einen gerenderten Quantencomputer schwappt; als glatt-glänzende Glasformen, die in einer Serie von Skulpturen aus dem Jahr 2022 von Sockeln und Simsen und um Rohre herum abrutschen. Und schließlich als eine durch das Schichten von Quanten-Videoprozessen entstandene Abstraktion in *SlimeCrawl* (2023), einer immersiven Installation, die Heaney im Auftrag des Shoreditch Arts Club in London realisierte.

Schleim ist eine quellende, dehnbare, atmende Substanz, ein Relikt der Natur. Seine taktilen Eigenschaften verweisen auf die ihm eigenen Intelligenzsysteme. Klassische Verschränkungen findet man überall: in den Myzelien von Pilzen, die ein Netzwerk unter dem Waldboden bilden und Nachrichten

2
James Bridle, Non-Binary Machines, Ways of Being: Beyond Human Intelligence, London 2022, S. 191–194.

zwischen Bäumen übermitteln, in den einzigartigen Zugmustern von Vögeln, und in der Tatsache, dass einige Schleimpilze räumliche Effizienzprobleme leichter lösen können als Computer.[2] Diese Systeme verkörpern die poetische Schnittstelle zwischen digitalen und natürlichen Netzwerken. Sie fordern uns auf, über die Grenzen unseres Körpers und unseres Verstandes hinauszugehen, um die uns umgebende Komplexität aktiv in den Blick zu nehmen. Aus der Akzeptanz und dem Verständnis dieser vielfältigen, konvergierenden und kooperierenden Entitäten entsteht eine neue Methodik des Denkens, Lebens und Seins. Als eine völlig andere ontologische Kategorie geht die Quantenverschränkung noch einen Schritt weiter. Wenn sich Schleimpilze quantenmechanisch verhielten, so würden sie gleichzeitig in allen möglichen räumlichen Konfigurationen existieren: sich ausdehnend, sich zusammenziehend, sich nach links verzweigend, aber auch nach rechts. Diese Zustände wären in einer Art Multiversum übereinander geschichtet – ein Phänomen, das in den sich überlagernden Video-Ebenen von slimeCrawl angedeutet ist.

Heaney verbindet sich mit ihrem Publikum auf intuitiver Ebene, indem sie Schleim zur Veranschaulichung der Quantenmechanik einsetzt. So lud sie zum Beispiel das Publikum zur Partizipation in einem interaktiven, immersiven Game-Environment ein, Ent- (many paths version), das 2022 im Gazelli Art House in London stattfand. Navigieren konnte man das Game mit einem Xbox-Controller, der beiläufig auf einer schleimigen, monströsen Skulptur zwischen den Spieler*innen platziert war. Zuvor hatte Heaney in einer anderen Arbeit den Schleim direkt dem Publikum in die Hände gelegt. slimeCore (2022) war eine immersive Videomontage und Live-Performance, mit der sie von der Zabludowicz Collection als Teil des Rahmenprogramms der Ausstellung Among the Machines beauftragt worden war. Dabei wurden Bilder direkt über und auf das Ausstellungsdisplay projiziert, wie eine Schicht neuer Materie, die vom Dach her in den Ausstellungsraum durchsickerte. Der Bildbearbeitungsprozess für diese Arbeit war ein Vorläufer desjenigen, der später im slimeCrawl-Video eingesetzt wurde. Die 5-Qubit-Quantenrechenleistung von IBM wurde genutzt, um schillernde Bildschichten zu erzeugen, während die wellenartigen Spitzen und Täler der Quantenüberlagerung und -verschränkung verschiedene Aspekte der Quellen-Videoclips freilegen.

3
Libby Heaney,
Skript für slimeQore
Performance, 2022.

n der Live-Performance von slimeQore wollte Heaney die Grenze zwischen Performerin und Betrachter*in überwinden. Dazu verteilte sie kleine schwarze Schachteln ans Publikum, die einen von der Künstlerin hergestellten Schleim enthielten. Anschließend trug Heaney auf der Bühne sitzend einen Text vor und ermutigte das Publikum dazu, an bestimmten Stellen während ihres Auftritts die Schachteln zu öffnen und mit dem Material zu spielen. Die in der Performance vermittelten Eigenschaften der Quantenwelt wurden mit einer spielerischen Absurdität sinnlich erfahrbar. Beeinflusst von der Quantenphysiker*in und feministischen Theoretiker*in Karen Barad nutzt Heaney Wortspiele, um die vielfältigen und entgrenzenden Konnotationen einer klebrigen, chaotischen Materialität zu erschließen. Heaney bezieht sich auf Barads Theorie, dass Menschen und Nicht-Menschen sich durch materielle und taktile Beziehungen, also durch Berührungen, herausbildeten: »Die Quantentheorie der Berührung ist radikal anders als die klassische Erklärung. Tatsächlich ist sie radikal queer. Ist das Berühren nicht von Natur aus immer eine Einholung, eine Einladung, eine Einfühlung, sei es gewollt oder ungewollt, des Fremden im Inneren? Ein Quantenqueering der Identität.«[3] Heaneys Gebrauch des Wortes »queer« zur Einordnung ihrer Arbeit knüpft an Barads Konzept des »radikal Unbändigen« an und betont damit die Perspektive einer grundlegenden Irritation des Hierarchien- und Ordnungsempfindens. Der Begriff »queer« wird damit weit über die menschliche Sexualität oder Genderidentität hinaus erweitert.

eaneys Praxis enthält eine Vielfalt von Bildern und Bedeutungsebenen, die dem Publikum ein sinnliches Erlebnis bieten, aber auch zu Reaktionen und Manipulationen einladen. Schleim wird abstrahiert, um die greifbare Materialität der Quantenwelt zu verkörpern. Die Substanz evoziert inhärent körperliche Eigenschaften: nass, sexy und feminin. Das Video slimeQrawl zeigt Schleim, der bemalte Lippen umschließt, und Schleim, der durch die Finger einer manikürten Hand gedrückt wird. In Kombination erinnern diese Elemente an die Inhalte von ASMR-Videos. In diesem Internetphänomen (ASMR steht für »autonomous sensory meridian response«, eine »autonome sensorische Meridianreaktion«) flüstern in Social-Media-Feeds beruhigende Stimmen, während Make-up aufgetragen oder Schleim sanft gepresst wird. Die Gesten und besonders die dabei erzeugten Geräusche vermitteln ein

wohltuendes, sexualisiertes Gefühl und versetzen die algorithmisch gefütterten Betrachter*innen in einen anderen Bewusstseinszustand. Die dislozierten Körperteile im Video sind Heaneys eigene – die Künstlerin fügt sich hier direkt in die Bildebene ein, statt wie in anderen Arbeiten als Präsenz auf der Bühne ein narratives Skript vorzutragen. Die Bilder dieser Körperteile verweben sich mit denen anderer Spezies, insbesondere Nahaufnahmen der sich windenden Körper von Schnecken: slimeCrawl ist in seinen Ursprüngen unverhohlen weiblich, wird aber durch die visuelle Sprache – geprägt von der endlosen Weite und Unfassbarkeit des Quantenraums – als queer codiert.

Trotz ihres komplexen Aufbaus liegt der Fokus von Heaneys Werken nicht in erster Linie auf dem Technischen oder Didaktischen. Charakteristisch ist vielmehr ihre Haptik sowie die Auseinandersetzung der Künstlerin mit den Schnittstellen zwischen der Quantenmechanik und den Strukturen von Gender, Sex, Identität und sozialer Schicht, die unsere Gegenwart prägen. In den umfassenden Welten, die sie schafft, stellt Heaney Phänomene wie Quantenverschränkung und non-binäre Zustände durch die spielerische Manipulation von Sprache, narrativen Konstruktionen und Metaphern wie Flüssigkeit und Schleim dar. Ihre vielfältige kritische Praxis setzt die besonderen Eigenschaften von Quantensystemen als Werkzeug und als künstlerisches Medium ein, um die Konstrukte zu hinterfragen, die wir gemeinhin als unsere Realität akzeptieren. Suggestiv verweist Heaney auf die Verbundenheit aller Dinge in der uns bekannten oder unbekannten Welt.

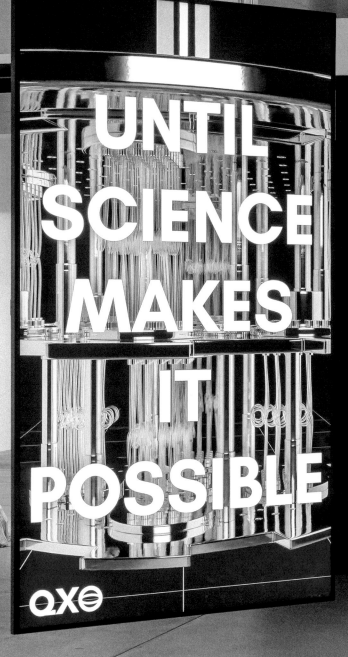

QX Extended Advertisement, 2022

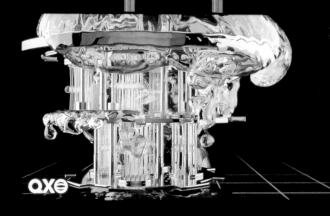

QX Product Launch Video

2022,
installation view /
Ausstellungsansicht

OX Product Launch Video, 2022

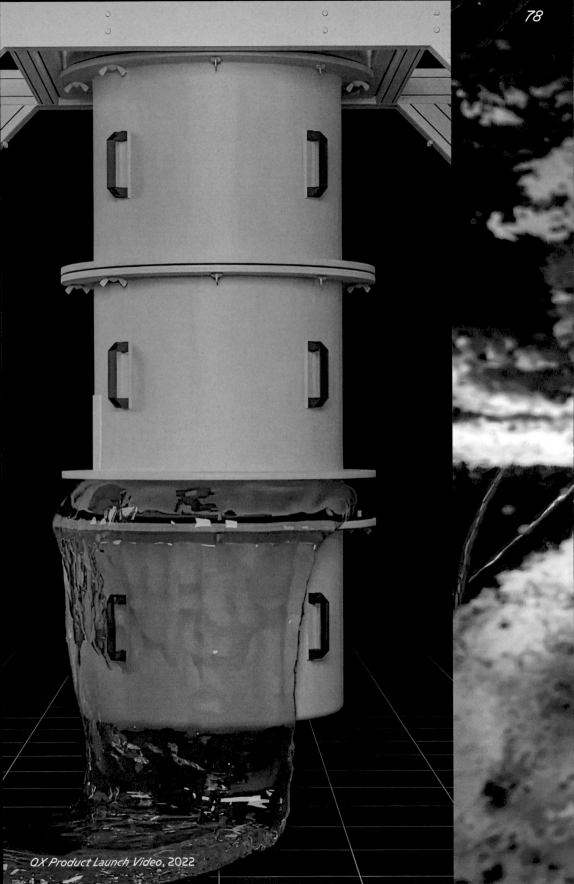

QX Product Launch Video, 2022

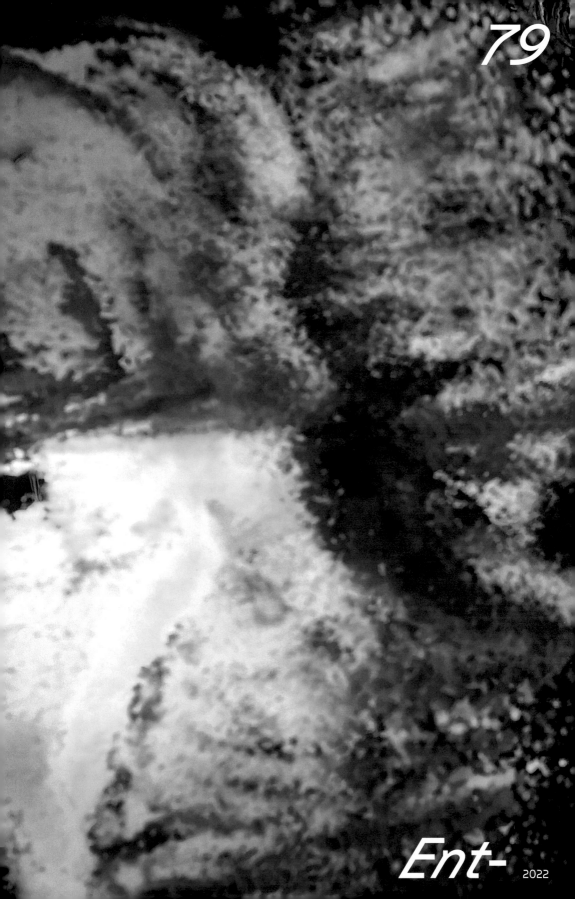

79

Ent-

2022

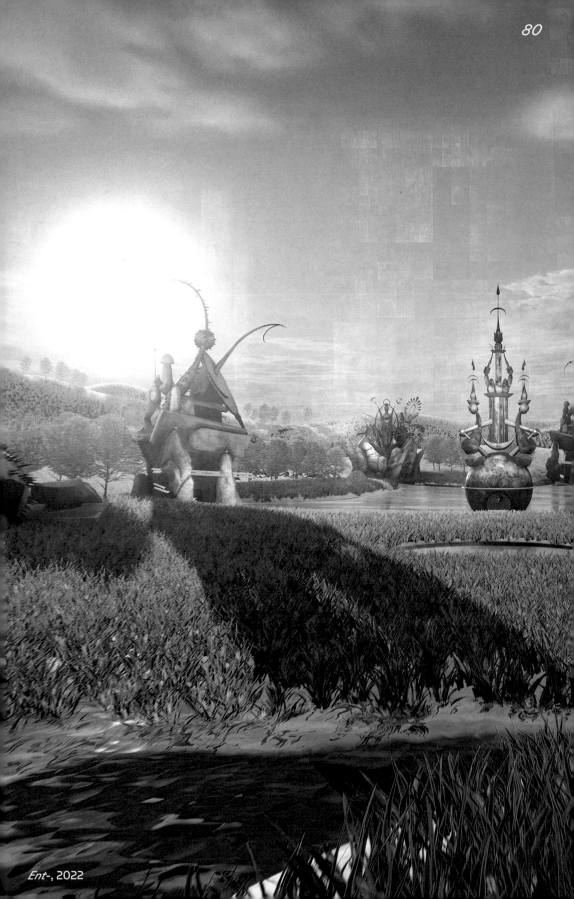

Ent-, 2022

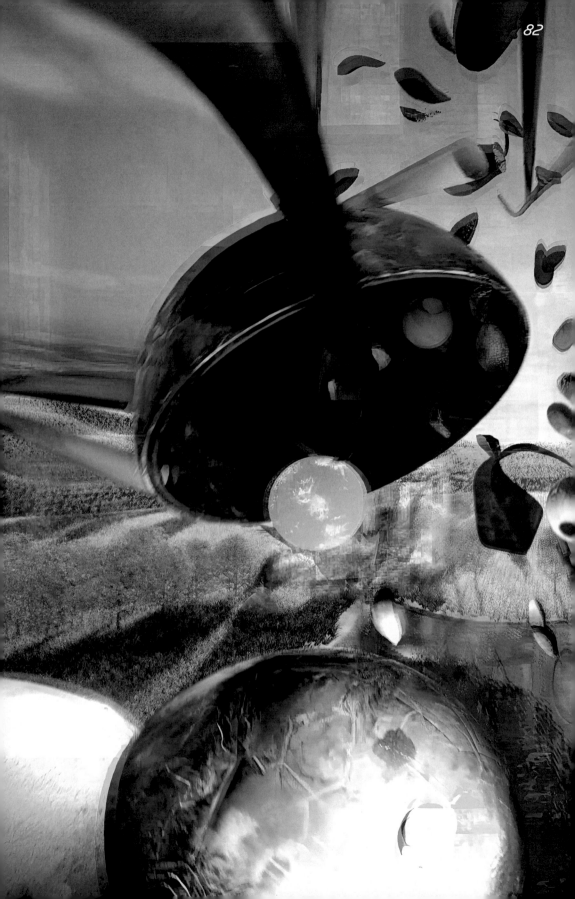

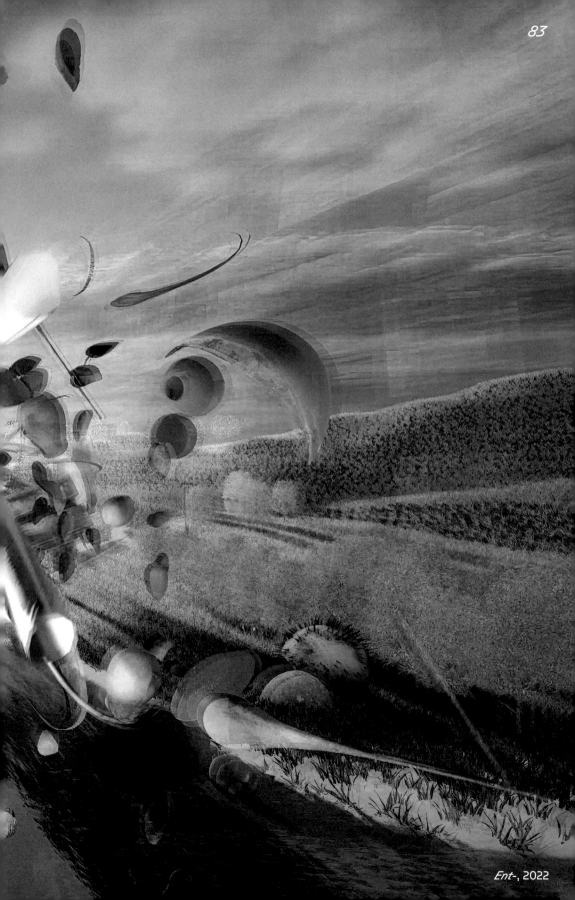

Ent-, 2022

Ent-, 2022, installation view / Ausstellungsansicht

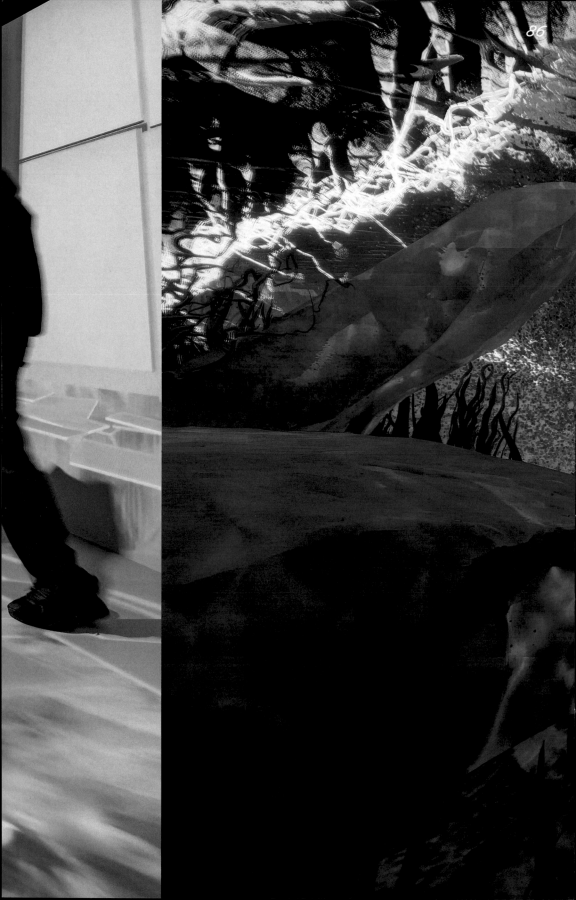

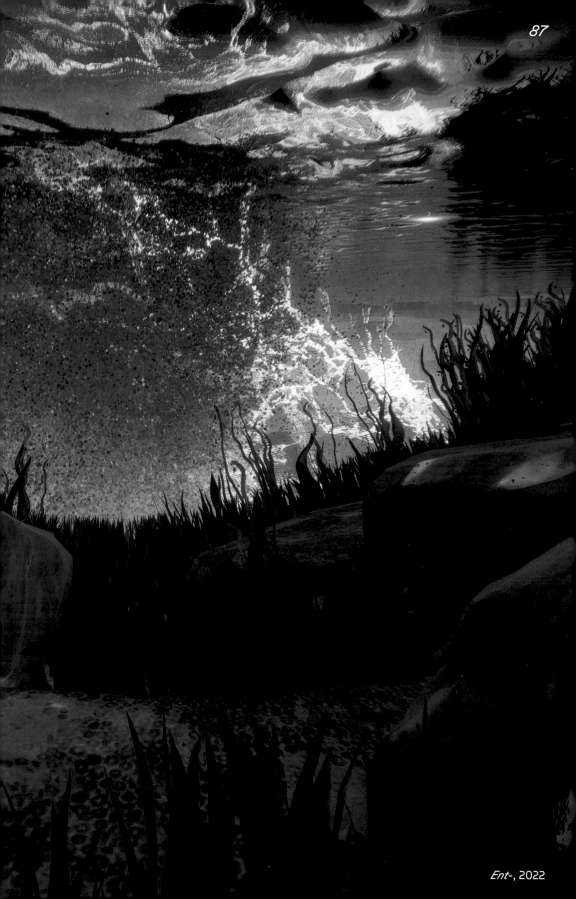

Ent-, 2022

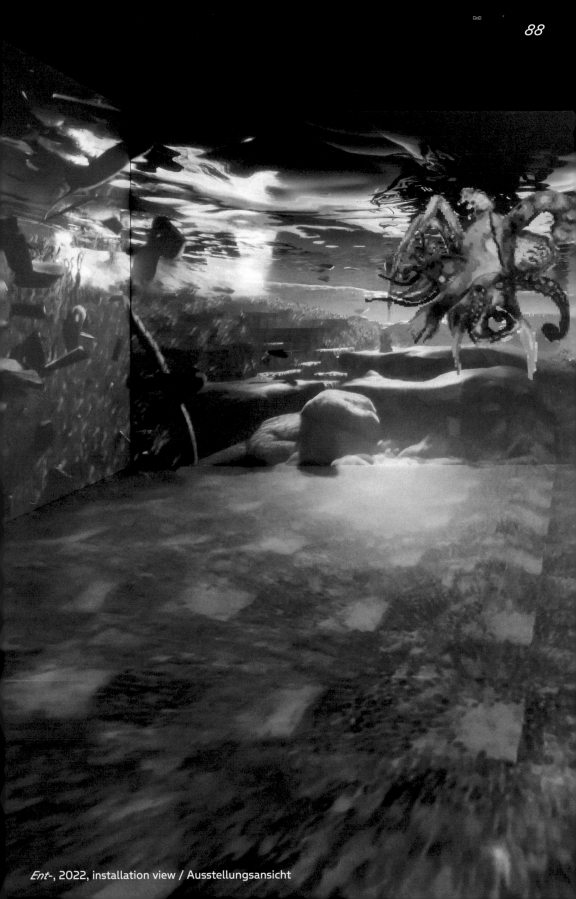

Ent-, 2022, installation view / Ausstellungsansicht

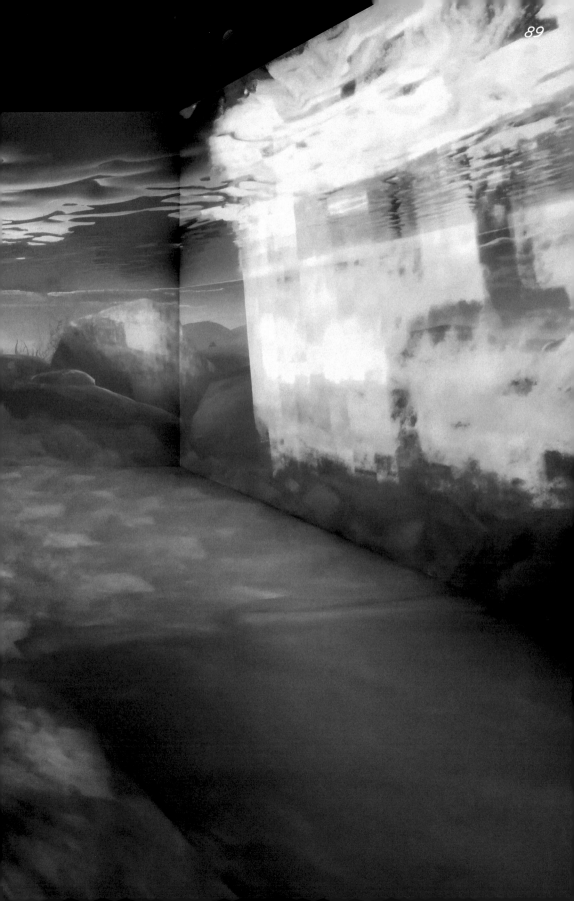

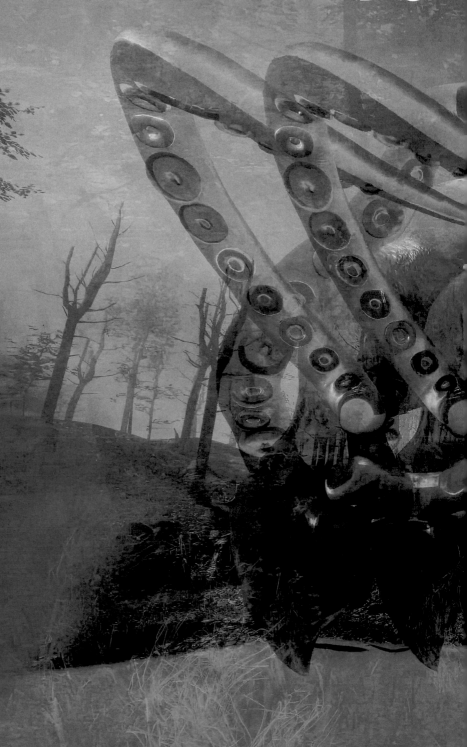

O is for Climate (?)

2023

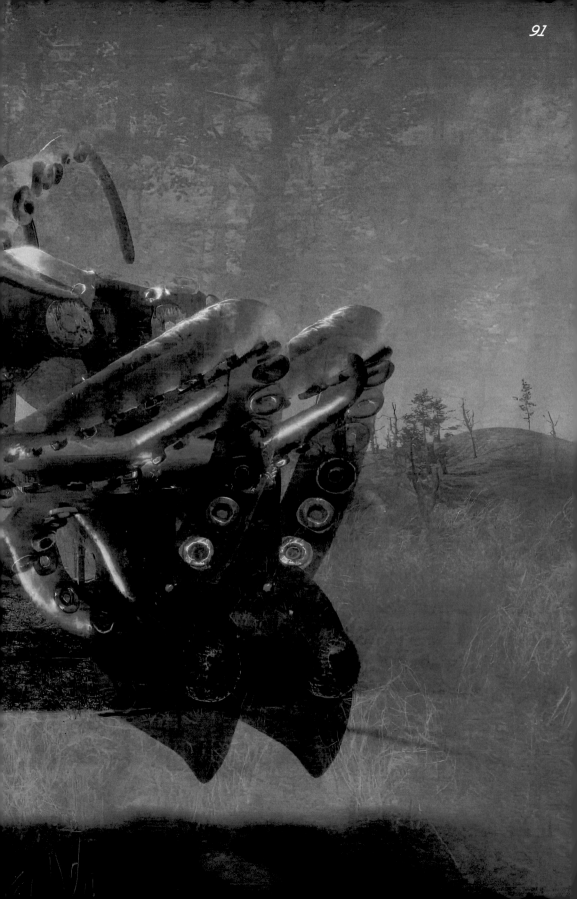

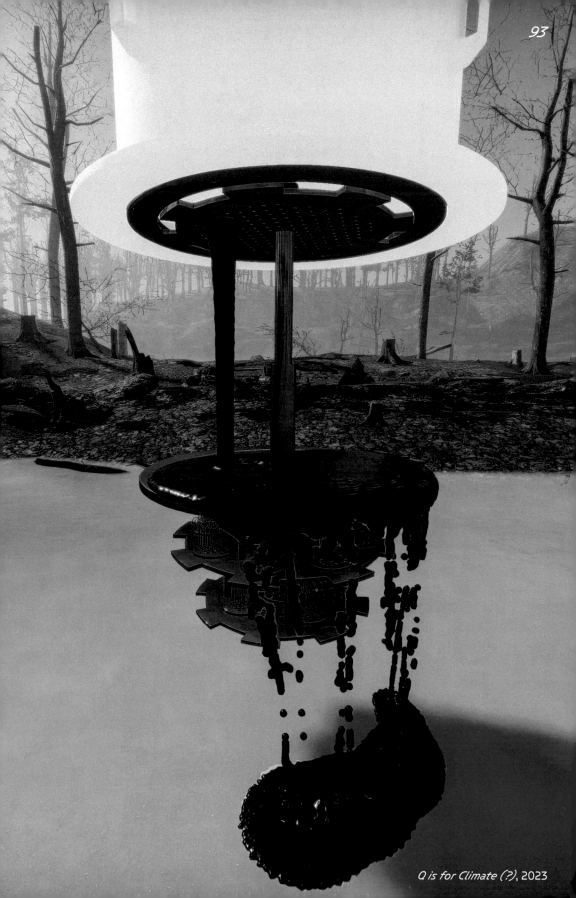

Q is for Climate (?), 2023

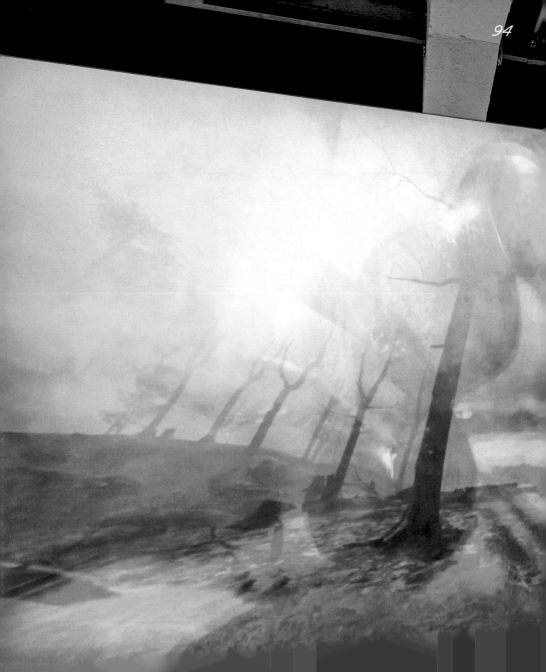

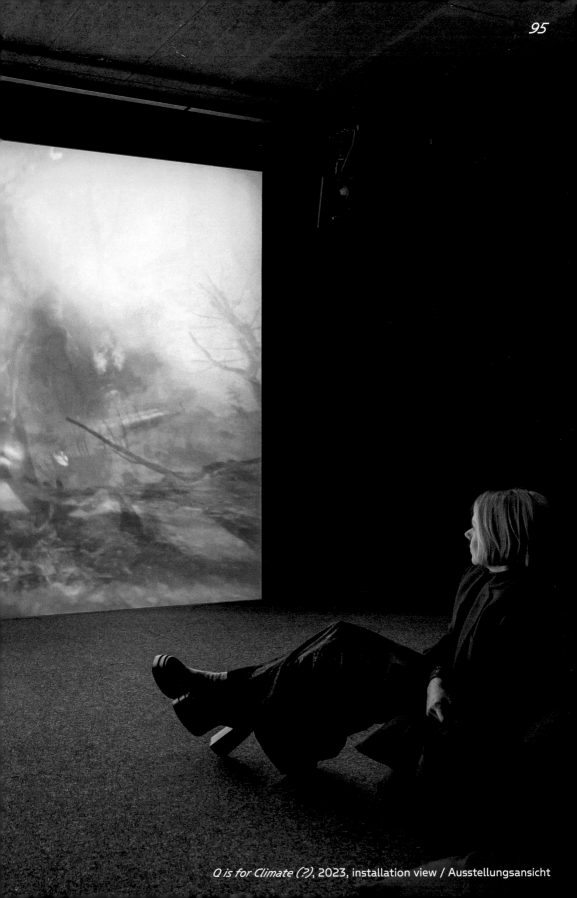

O is for Climate (?), 2023, installation view / Ausstellungsansicht

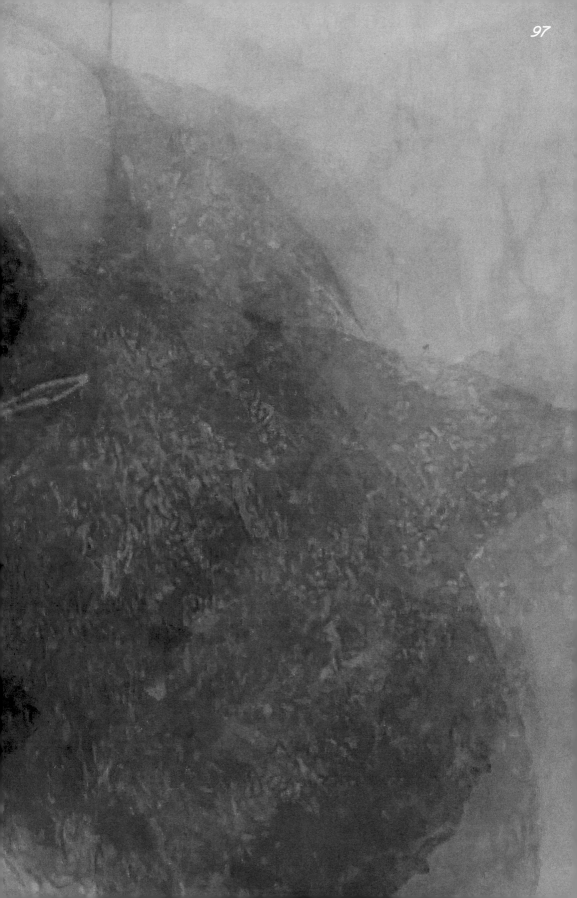

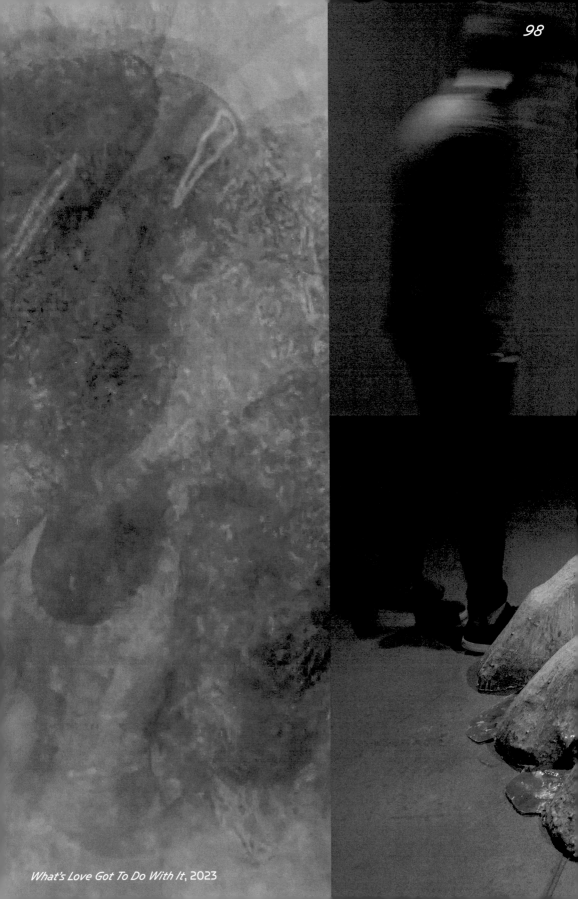

What's Love Got To Do With It, 2023

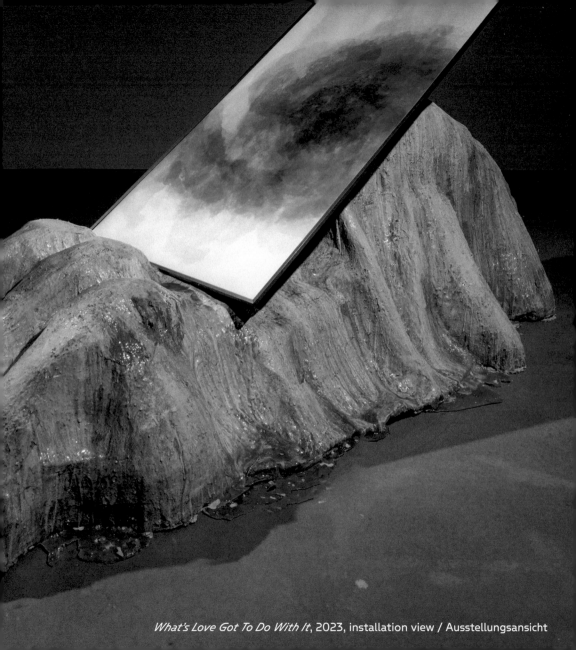

What's Love Got To Do With It, 2023, installation view / Ausstellungsansicht

Installation view / Ausstellungsansicht

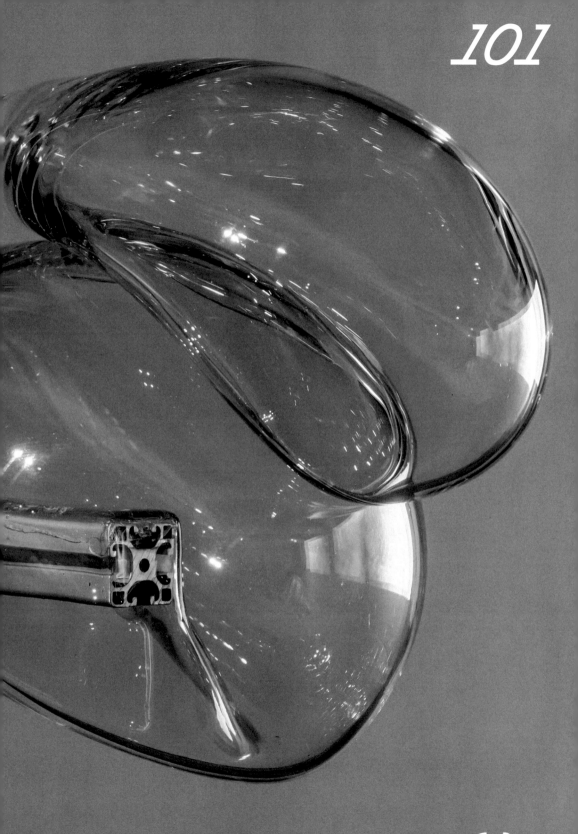

Supraphrodite (i) 2024

Never Too Much

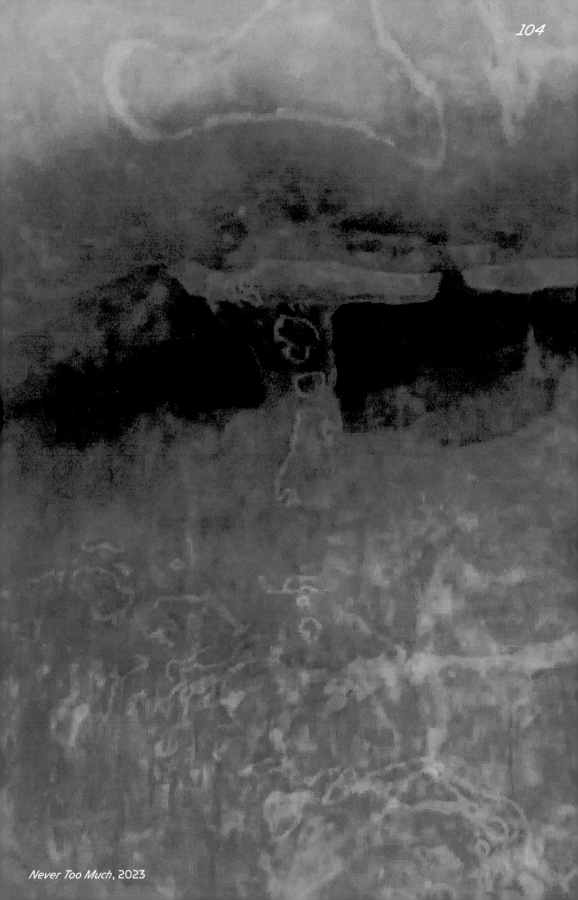

Never Too Much, 2023

Never Too Much, 2023

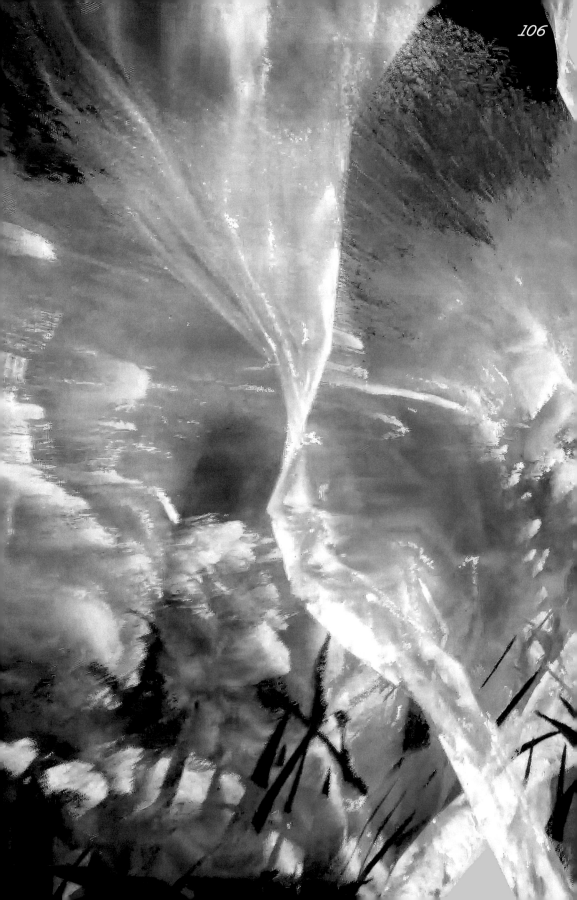

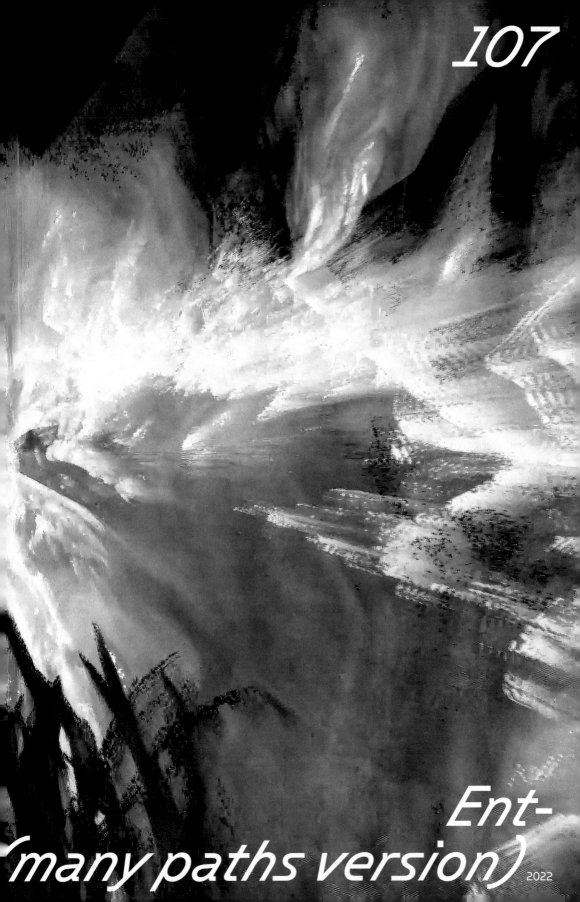

Ent-
(many paths version) 2022

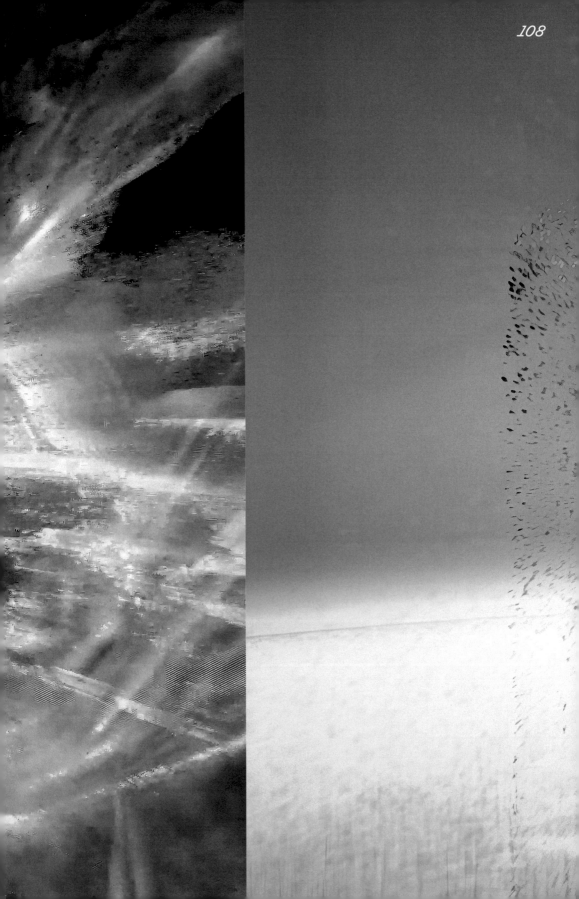

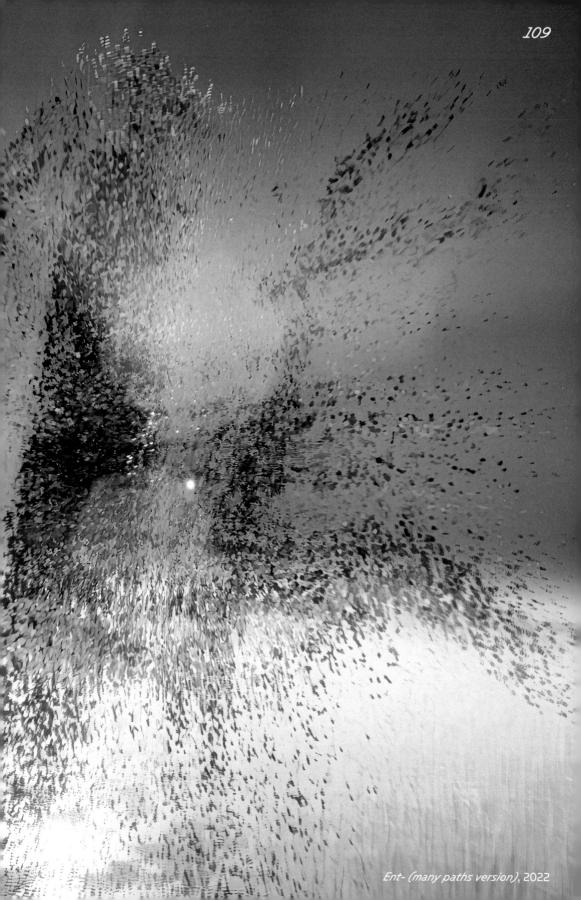

Ent- (many paths version), 2022

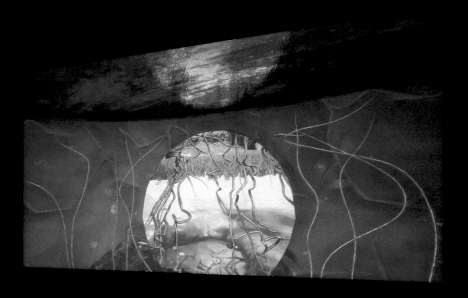

Ent- (many paths version), 2022, installation view / Ausstellungsansicht

112

slimeQrawl 2023

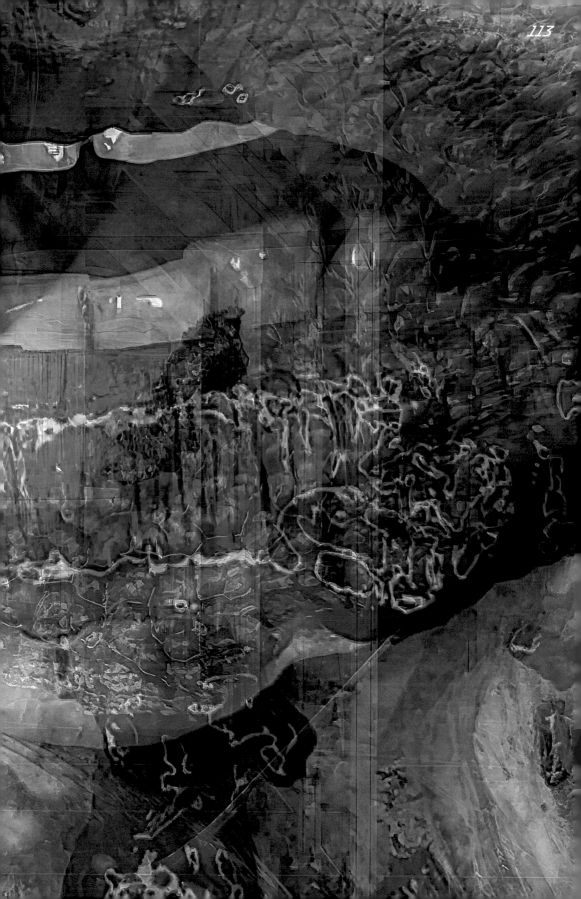

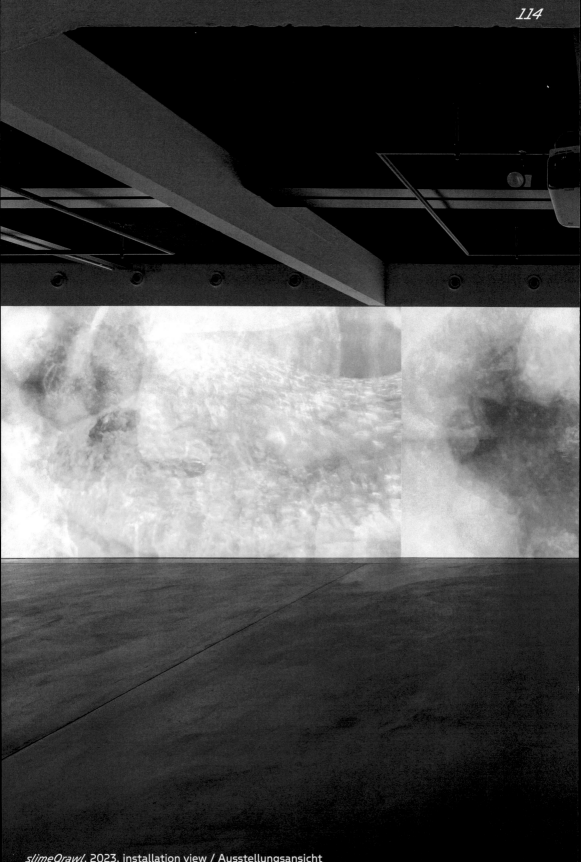

slimeOrawl, 2023, installation view / Ausstellungsansicht

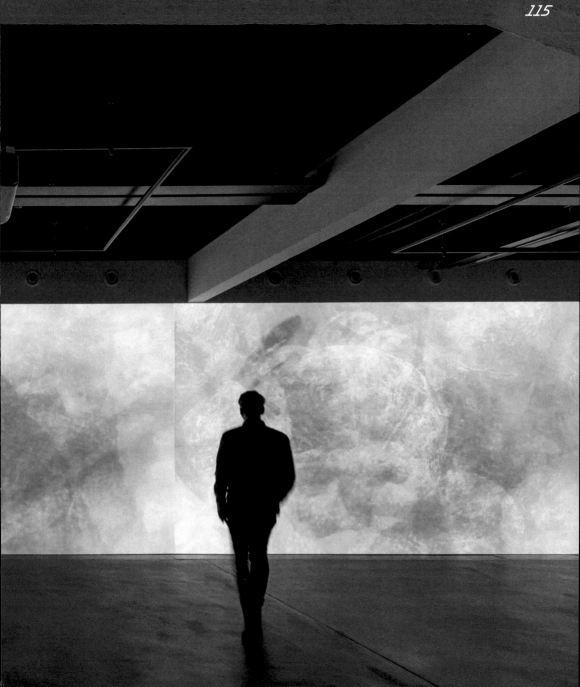

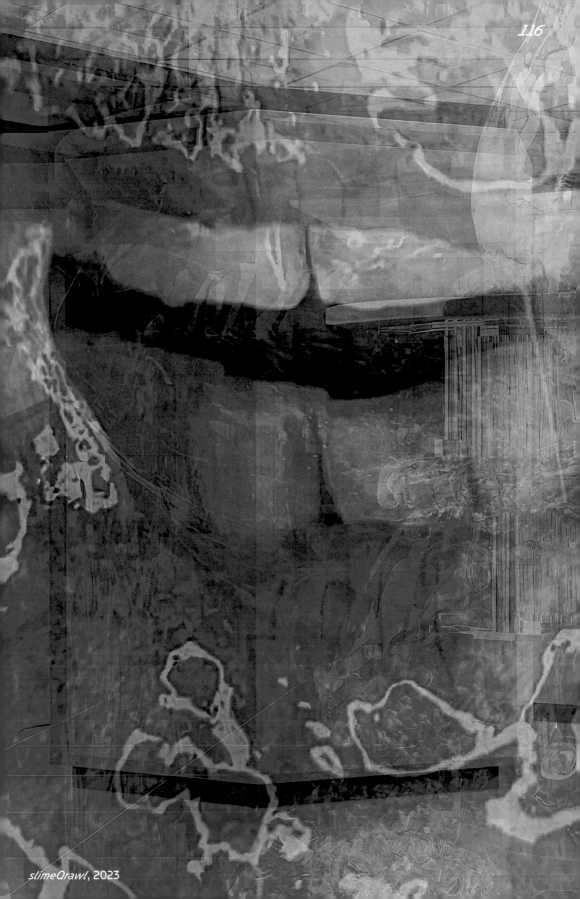

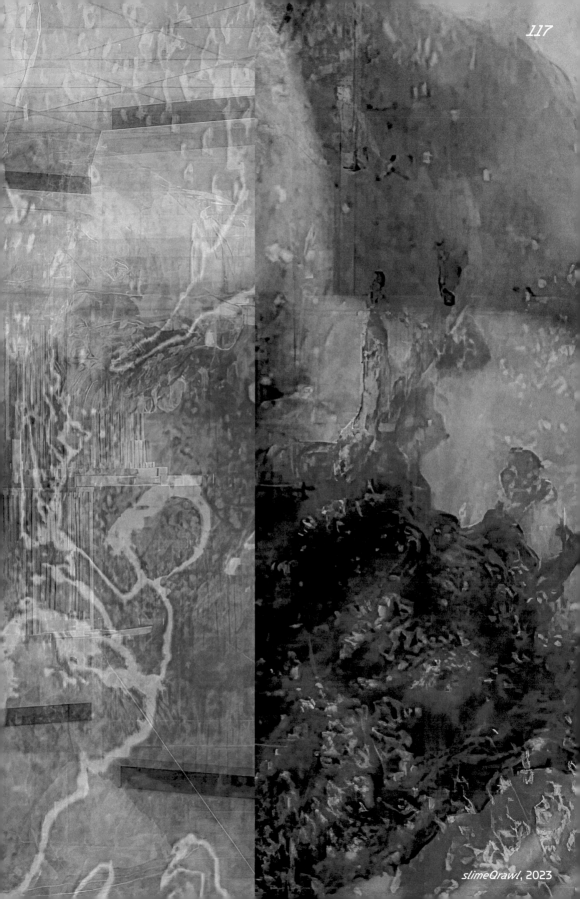

slimeQrawl, 2023

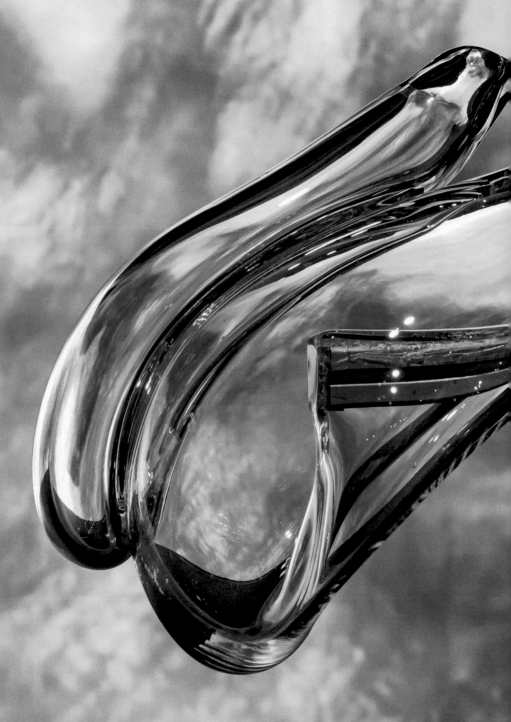

Supraphrodite (ii) 2024

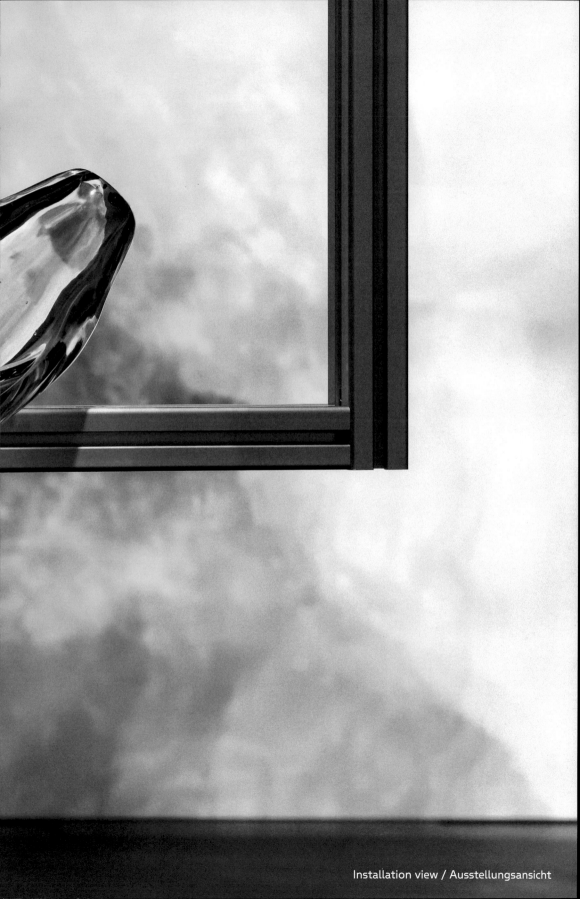

Installation view / Ausstellungsansicht

Please Don't Cry 2023

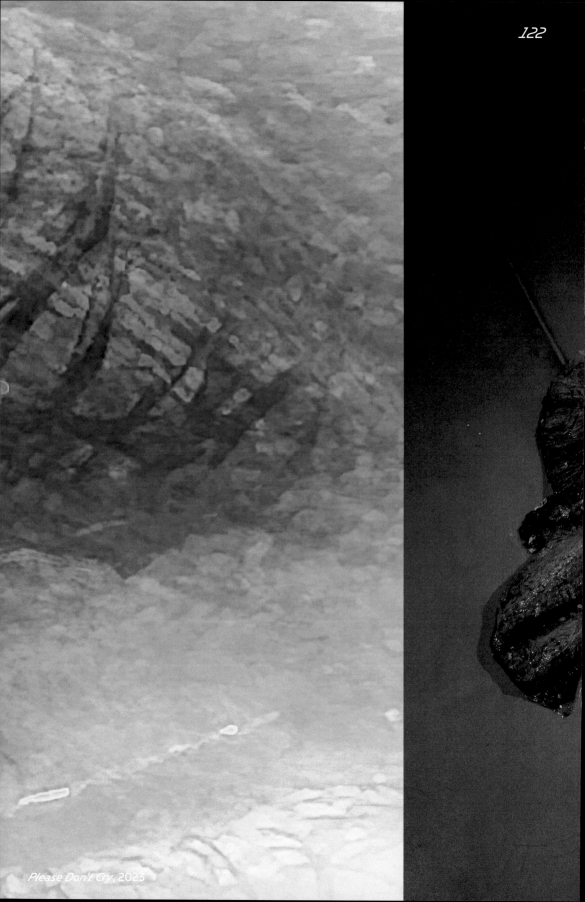

Please Don't Cry, 2023

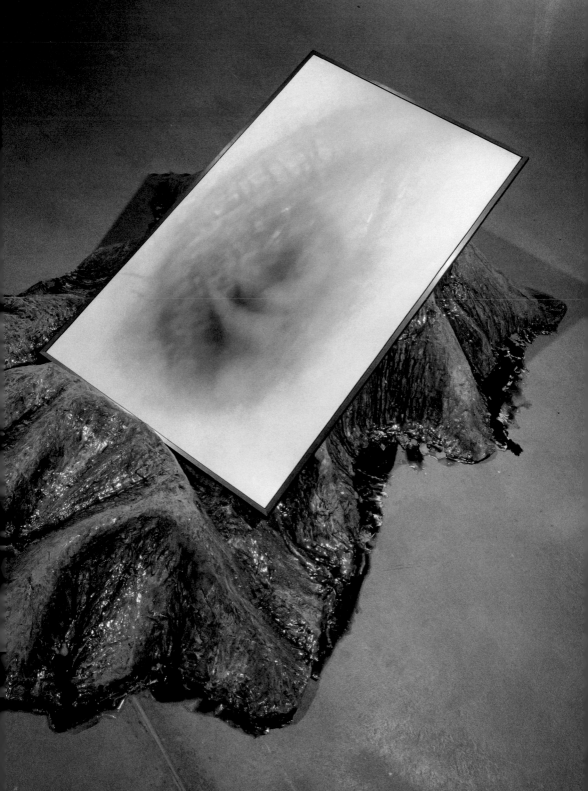

Please Don't Cry, 2023, installation view / Ausstellungsansicht

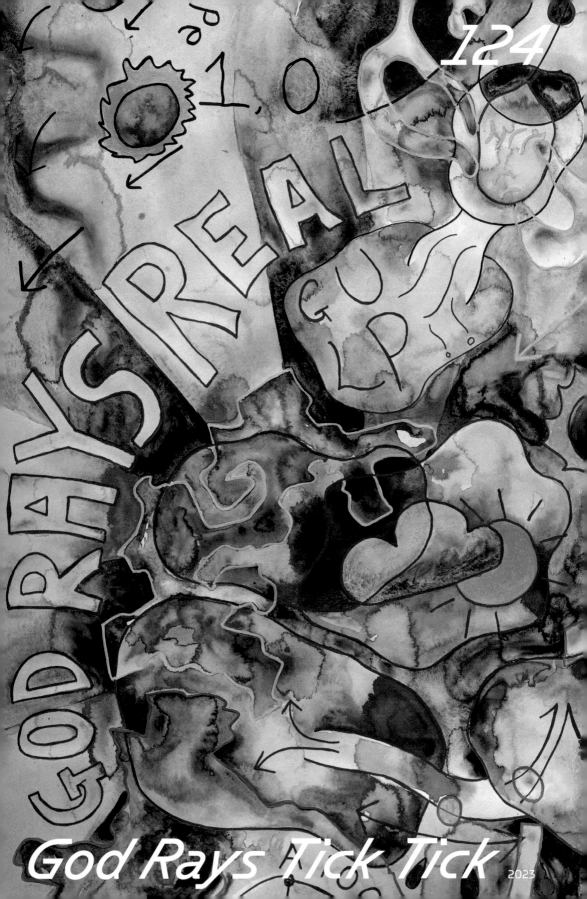

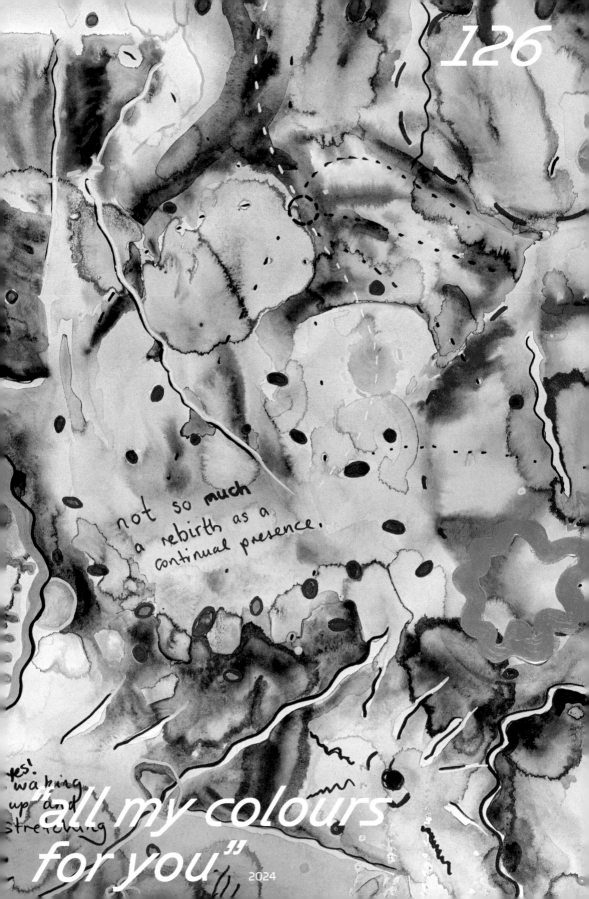

not so much
a rebirth as a
continual presence.

yes!
waking
up "and
stretching

"all my colours
for you"

2024

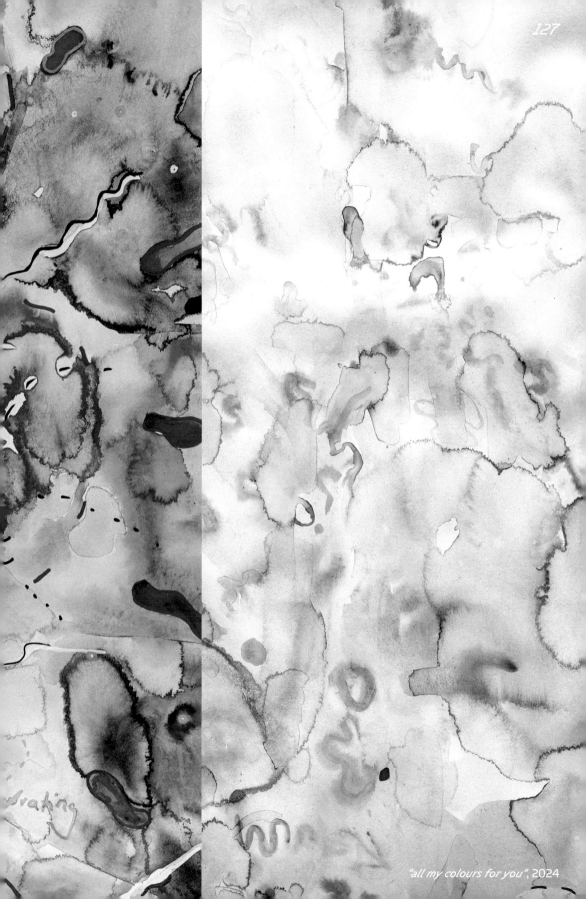

"all my colours for you", 2024

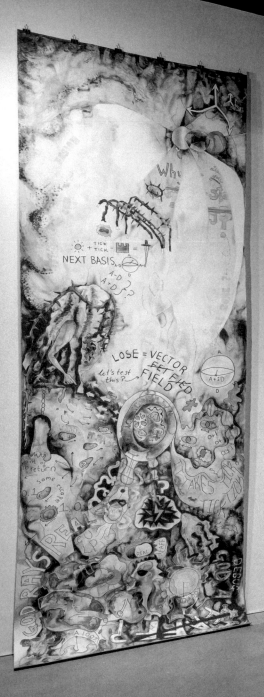

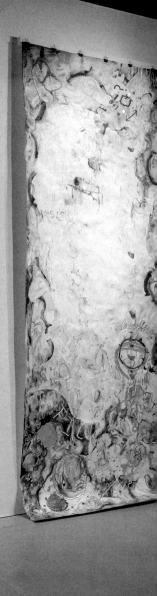

God Rays Tick Tick, 2023, *"all my colours for you"*, 2024, installation view / Ausstellungsansicht

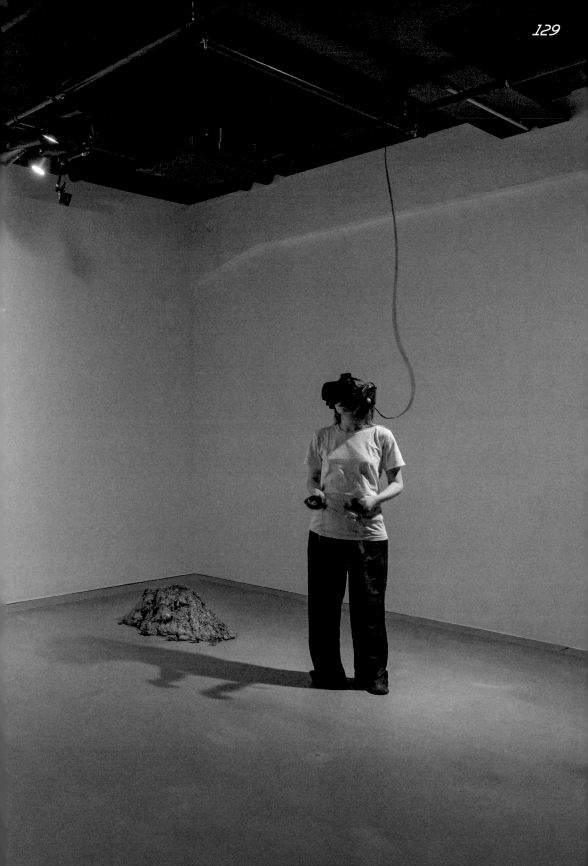

Heartbreak and Magic, 2024, installation view / Ausstellungsansicht

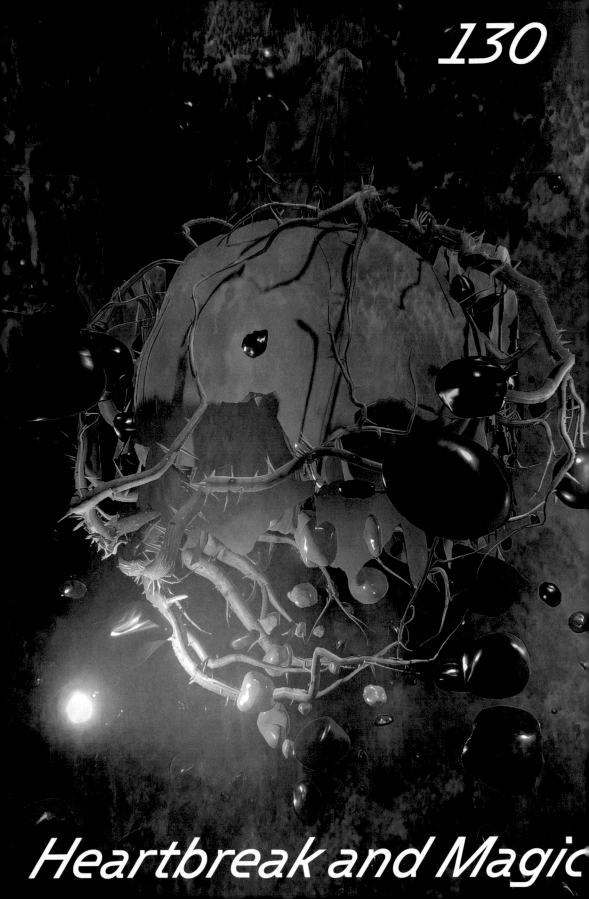

Heartbreak and Magic

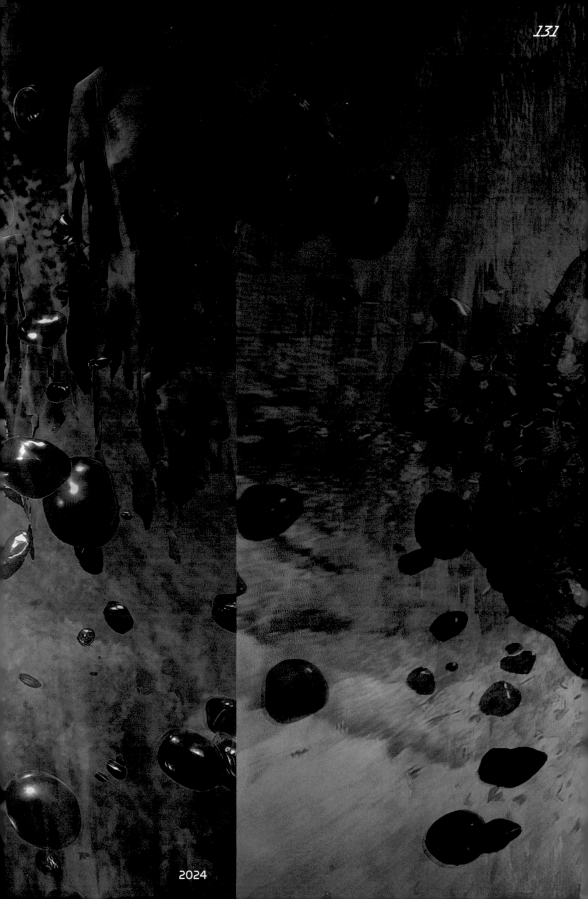

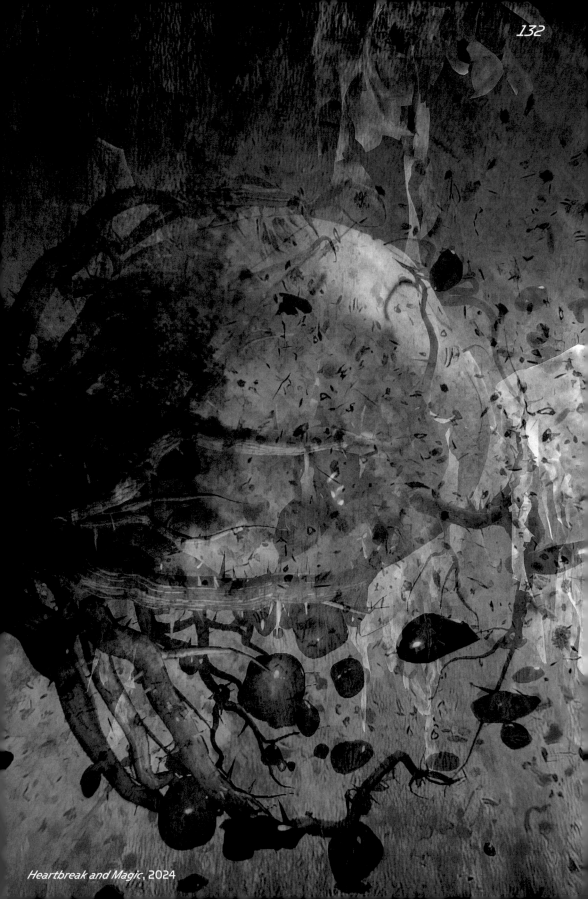

Heartbreak and Magic, 2024

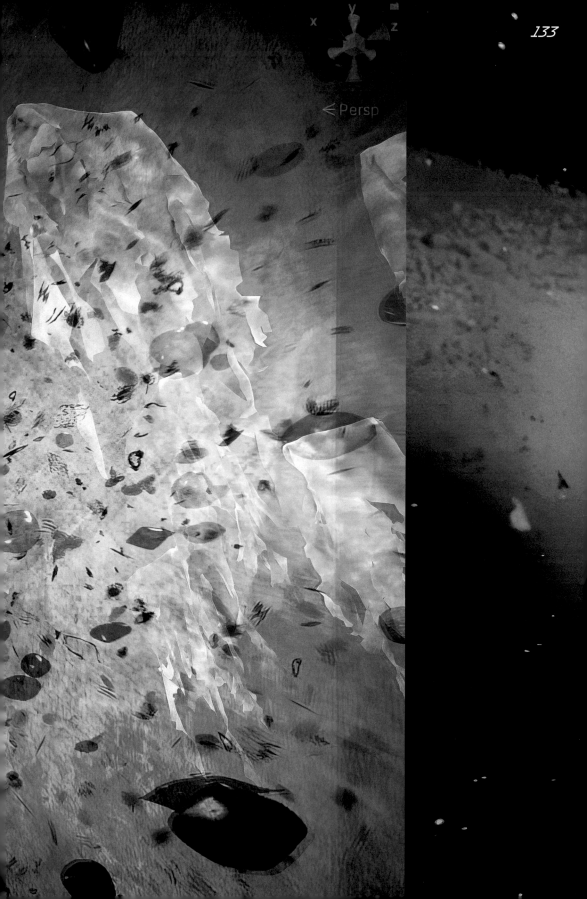

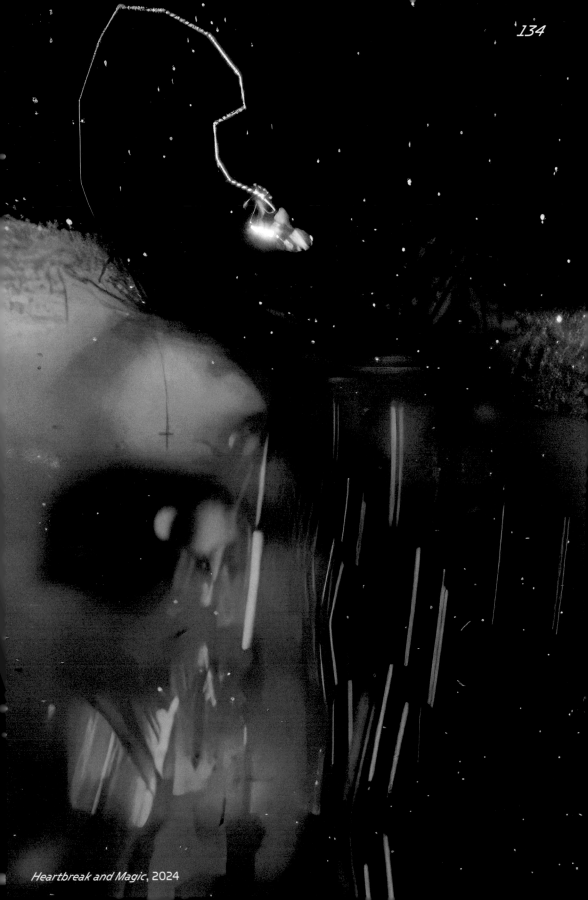

Heartbreak and Magic, 2024

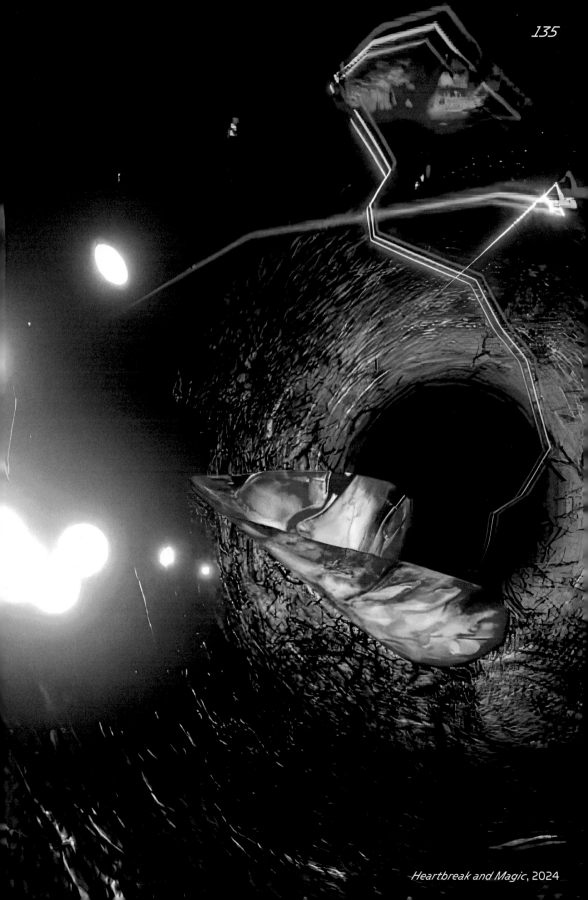

Heartbreak and Magic, 2024

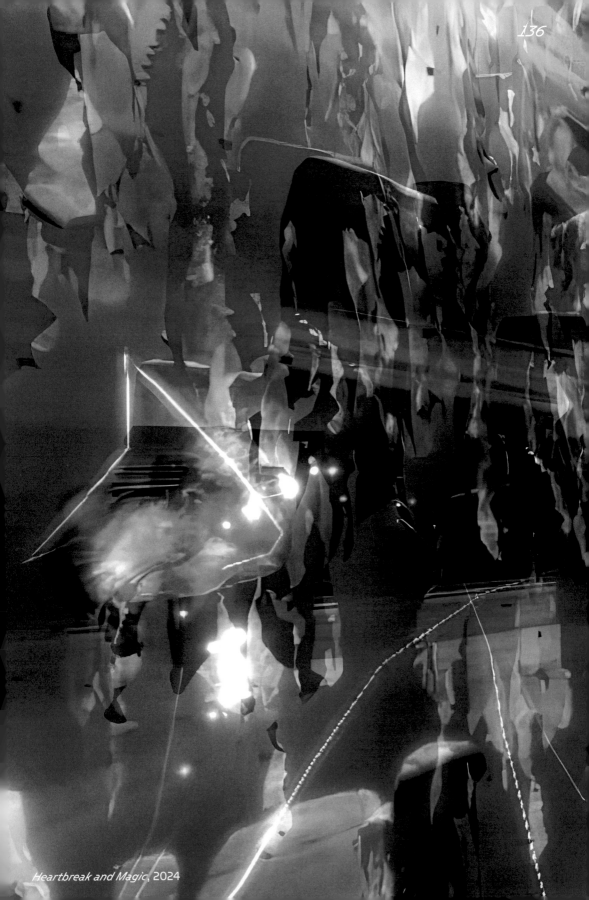

Heartbreak and Magic, 2024

QX Extended Advertisement, 2022
Video, no sound / Video, ohne Ton
5:57 min. / Min.

QX Product Launch Video, 2022
video, 4k with sound /
Video, 4k mit Ton
4:29 min. / Min.

Ent-, 2022
5 channel video projection, immersive
360 degree projection with 4 channel
sound / 5-Kanal-Videoinstallation,
immersive 360-Grad-Projektion mit
4-Kanal-Ton
10 min. / Min.

Q is for Climate (?), 2023
Single channel video, 4k with sound /
Einkanal-Video, 4k mit Ton
7:38 min. / Min.

What's Love Got To Do With It, 2023
Single channel video, no sound /
Einkanal-Video, ohne Ton
10 min. / Min.

Supraphrodite (i), 2024
Glass sculpture / Glasskulptur
34 × 34 × 27 cm

Never Too Much, 2023
Single channel video, no sound /
Einkanal-Video, ohne Ton
18 min. / Min.

Ent- (many paths version), 2022
Single screen, Xbox controller, gaming
PC, Unreal engine 4 environment with
quantum computing / Bildschirm,
Xbox-Controller, Gaming-PC, Unreal-
Engine-4-Umgebung mit Quanten-
computing
Duration variable / Dauer variabel

slimeQrawl, 2023
3 channel video projection, no sound /
3-Kanal-Videoinstallation, ohne Ton
14:22 min. / Min.

Supraphrodite (ii), 2024
Glass sculpture / Glasskulptur
48 × 27 × 33 cm

Please Don't Cry, 2023
Single channel video, no sound /
Einkanal-Video, ohne Ton
34 min. / Min.

"all my colours for you", 2024
Watercolour, acrylic paint and acrylic
marker / Aquarell, Acrylfarbe und
Acrylmarker
348 × 115 cm

God Rays Tick Tick, 2023
Watercolour, acrylic paint and acrylic
marker / Aquarell, Acrylfarbe und
Acrylmarker
346 × 115 cm

Heartbreak and Magic, 2024
VR-Experience
Duration variable / Dauer variabel
Commissioned by VIVE Arts /
Beauftragt durch VIVE Arts

All works courtesy of the artist /
Sämtliche Werke mit freundlicher
Genehmigung der Künstlerin

Libby Heaney is an award-winning visual artist with a PhD & professional research background in Quantum Information Science. She is widely known as the first artist to work with quantum computing as a functioning artistic medium.

Heaney's practice explores inherently queer, non-local and hybrid concepts from quantum science to disrupt binary categories and hierarchies and foster radical interconnectedness. Her works combine diverse mediums such as performance, moving image, glass and watercolour with cutting-edge technologies including machine learning, game engines and quantum computing, entangling interior landscapes with the impact of the exterior realm.

Crucially Heaney's works continuously seek to expand the possibilities of the individual and the collective through the magic of quantum, transcending capitalist uses of technology.

Through the ambivalent mechanisms and logic of quantum, Heaney creates new non-linear modes of affective storytelling, blurring fact and fiction and embracing both narrative and intuitive visceral embodied experiences.

As a scientist Heaney worked at the University of Oxford and National University of Singapore, publishing 20 physics papers in top peer reviewed journals. She was the recipient of the HSBC and Institute of Physics, Very Early Career Woman in Physics award. In 2015 Heaney graduated from Central St. Martins, London with a focus on AI and kinetic sculpture.

Since then, Heaney has exhibited at major institutions and museums in the UK and internationally such as Ars Electronica, Linz; Tate Modern, London; V&A Museum, London. Her significant solo exhibitions and performances include *Quantum Soup*, HEK, Basel; *Heartbreak and Magic*, Somerset House, London; *The Evolution of Ent-: QX*, arebyte Gallery, London; *The Whole Earth Chanting*, Sonar Festival, Barcelona; *CASCADE*, Southbank Centre, London and *Ent-*, LAS Art Foundation, Berlin. From 2017 to 2024 she was a resident of Somerset House Studios in London, and in 2022 Heaney won the Lumen Prize and Falling Walls Art & Science award.

Libby Heaney ist eine preisgekrönte Künstlerin und promovierte Quanteninformatikerin. In der Arbeit mit Quantencomputern als funktionsfähigem künstlerischem Medium gilt sie als Pionierin.

Heaney erforscht in ihren Werken inhärent queere, nichtlokale und hybride Konzepte aus der Quantenwissenschaft, um so binäre Kategorien und Hierarchien aufzubrechen und eine radikale Vernetzung anzutreiben. Sie verbindet dabei Medien wie Performance, Bewegtbild, Glas und Aquarell mit modernen Technologien wie maschinellem Lernen, Spiel-Engines und Quantencomputern und verschränkt in diesem Prozess innere Landschaften mit Einflüssen der Außenwelt.

Besonders an Heaneys Arbeiten ist, wie diese die Möglichkeiten des Individuums und des Kollektivs durch die Magie der Quanten ständig erweitern und sich über die kapitalistische Nutzung von Technologie hinwegsetzen. Durch die ambivalenten Mechanismen und die Logik der Quantentechnologie schafft Heaney neue, nichtlineare Formen affektiven Erzählens, in denen Fakten und Fiktion verschwimmen, und die sowohl erzählerische als auch intuitive, viszerale, verkörperte Erfahrungen umfassen. Als Wissenschaftlerin arbeitete Heaney an der Universität Oxford und der National University of Singapore und veröffentlichte in führenden Physik-Fachzeitschriften. Sie wurde mit dem Very Early Career Female Physicist Award des britischen Institute of Physics ausgezeichnet. 2015 schloss sie ihr Studium am Central Saint Martins College in London mit den Schwerpunkten KI und kinetische Skulptur ab.

Seitdem hat Heaney in Institutionen und Museen im Vereinigten Königreich und international ausgestellt, unter anderem im Ars Electronica, Linz, in der Tate Modern, London, und im V&A Museum, London. Zu ihren wichtigsten Einzelausstellungen und Performances gehören Quantum Soup, HEK (Haus der Elektronischen Künste), Basel; Heartbreak and Magic, Somerset House, London; The Evolution of Ent-, QX, arebyte Gallery, London; The Whole Earth Chanting, Sonar Festival, Barcelona; CASCADE, Southbank Centre, London, und Ent-, LAS Art Foundation, Berlin. Von 2017 bis 2024 war Heaney Residentin der Somerset House Studios in London. 2022 gewann sie den Lumen Prize und den Falling Walls Art & Science Award.

Authors' biographies

Amira Gad

Amira Gad is a curator and writer based in Rotterdam, the Netherlands. She is currently curator at large, Arts Technologies at KANAL-Centre Pompidou in Brussels as well as head of exhibitions at Het HEM in the Netherlands. Gad was previously head of programs at the then newly established Berlin-based LAS Art Foundation, which works at the intersection of art and technology and where she spearheaded the establishment of the organization and its artistic program in the local and international art scene. From 2014 to 2020, she was curator at the Serpentine Galleries in London, and managing curator at Kunstinstituut Melly (formerly known as Witte de With Center for Contemporary Art) in Rotterdam, where she worked from 2009 to 2014. Over the years, Gad has curated exhibitions by Ian Cheng, Sondra Perry, Arthur Jafa, Hito Steyerl, Zaha Hadid, Simon Denny, and Lynette Yiadom-Boakye, amongst others. A number of her shows have travelled to various institutions across the world and received awards such as the AICA Award for Best Exhibition and the Sky Arts Award for visual arts.

Gad has been on a number of juries, including for the Oskár Čepan Award 2022 and 2023, OGR Award 2023, Prix de Rome 2019 and 2021 in Visual Arts, and the International Film Festival Rotterdam (IFFR)'s Ammodo Tiger Short Awards 2021. She is a regular contributor to artists' catalogues and has edited several books on contemporary art. Gad was also commissioning editor for Ibraaz (ibraaz.org), an online platform dedicated to visual culture in the Middle East and North Africa that existed between 2012 and 2017. She sits on the board of Rib Art Space, a project space in Rotterdam, and on the program board of Extra Extra magazine.

Julia Greenway

Julia Greenway is a London-based curator who focuses on how digital media influences the aesthetic presentation of gender, economics, and environment. Currently a curator at the Zabludowicz Collection, London, she co-curated the solo exhibition by artist LuYang and the thematic group exhibition Among the Machines. Upon relocating to London in 2018, she independently produced Gery Georgieva's UWU Channel Radiance at Cubitt Artists and the site-specific installation Semelparous by Joey Holder in the abandoned Springhealth Leisure Centre. Previous roles include curator in residence with Oregon Contemporary in Portland, Oregon, 2017-18, and curatorial director of Interstitial, a contemporary new media gallery in Seattle, Washington from 2015. Greenway holds an MFA in curating from Goldsmiths, University of London, and a BFA in painting from Grand Valley State University in Michigan.

Sabine Himmelsbach

Since 2012, Sabine Himmelsbach has been director of HEK (House of Electronic Arts) in Basel. After studying art history in Munich she worked for galleries in Munich and Vienna from 1993–1996 and later became project manager for exhibitions and conferences for the Steirischer Herbst Festival in Graz, Austria. In 1999 she became exhibition director at the ZKM | Center for Art and Media in Karlsruhe. From 2005–2011 she was the artistic director of the Edith-Russ-House for Media Art in Oldenburg, Germany. In 2011 she curated *gateways. Art and Networked Culture* for the Kumu Art Museum in Tallinn as part of the European Capital of Culture Tallinn 2011 program. Her exhibitions at HEK in Basel include *Ryoji Ikeda* (2014); *Poetics and Politics of Data* (2015); *Rafael Lozano-Hemmer: Preabsence* (2016); *unREAL* (2017); *Lynn Hershman Leeson: Anti-Bodies, Eco-Visionaries* (2018); *Entangled Realities. Living with Artificial Intelligence* (2019); and *Making FASHION Sense* and *Real Feelings. Emotion and Technology* (2020). In 2022 she curat-

ed *Earthbound – In Dialogue with Nature* for the European Capital of Culture Esch-sur-Alzette in Luxembourg. Recent shows have been *Collective Worldbuilding – Art in the Metaverse* and *Exploring the Decentralized Web – Art on the Blockchain* (both 2023). As a writer and lecturer she is dedicated to topics related to media art and digital culture.

Ariane Koek

Ariane Koek is internationally known as a consultant, producer, curator, and writer in the field of arts, science, technology, and ecology with a special interest in the new frontiers of physics. In 2009 she initiated and designed the Arts at CERN program, directing it, including the Collide residencies, until 2015. Since then, she has worked independently for international foundations, philanthropists, museums, universities, and government institutions around the world. These include the European Commission; Wellcome; the Exploratorium USA; the Endowment Fund of the International Red Cross Committee (FICRC); Pro Helvetia (The Swiss Arts Council) Science Gallery International; and Cavendish Laboratories at the University of Cambridge.

In 2022 she was awarded a Bogliasco Fellowship, and in 2021 was invited as a creative director of the official Italian Virtual Pavilion during the Venice Biennale of Architecture. Ariane is on the cultural boards of HeK (House of Electronic Arts) Basel, Switzerland; Edgelands Institute (Harvard University/Geneva); AND (Abandon Normal Devices) Manchester, UK; and the European Commission's Joint Research Centre, Ispra, Italy, which is dedicated to environmental scientific research and policy-making across Europe. Ariane is also a Clore Fellow, Salzburg Global Fellow, and fellow of the Royal Society of Arts (FRSA). Her publications include *Entangle: Physics and the Artistic Imagination* (Hatje Cantz).

Paul Luckraft

Paul Luckraft is a London-based curator and writer with a particular focus on the impact of contemporary technology on art, society, and the self. As senior curator at Zabludowicz Collection, London until February 2023, he presented major solo exhibitions by artists such as LuYang, Shana Moulton, and Rachel Maclean, each featuring newly commissioned works. Paul also curated thematic group exhibitions, including *Among the Machines*, *You Are Looking at Something That Never Occurred*, and *Emotional Supply Chains*. In addition, he led the development of the Zabludowicz Collection Invites program, which supported UK-based emerging artists through solo presentations, curating over 35 such exhibitions. Alongside exhibition delivery Paul has edited and contributed texts across numerous publications. Previous roles include curator at Modern Art Oxford and assistant curator at FACT, Liverpool. In 2006 he was part of the team that established The Royal Standard artist-run studios and project space in Liverpool. Paul holds an MA in art history from the UK-based Open University and a BA in Fine Art from Liverpool John Moores University.

Amira Gad

Amira Gad ist Kuratorin und Autorin und lebt in Rotterdam, Niederlande. Sie ist Curator at Large, Arts Technologies am KANAL-Centre Pompidou in Brüssel sowie Ausstellungsleiterin am Het HEM in den Niederlanden. Zuvor leitete sie das Programm bei der damals neu gegründeten LAS Art Foundation in Berlin, die an der Schnittstelle von Kunst und Technologie arbeitet, und war dort verantwortlich für die Etablierung der Organisation und ihres künstlerischen Programms in der lokalen und internationalen Kunstszene. Von 2014 bis 2020 war sie Kuratorin an den Serpentine Galleries in London und von 2009 bis 2014 geschäftsführende Kuratorin am Rotterdamer Kunstinstituut Melly (ehemals Witte de With Center for Contemporary Art). Gad hat unter anderem Ausstellungen von Ian Cheng, Sondra Perry, Arthur Jafa, Hito Steyerl, Zaha Hadid, Simon Denny und Lynette Yiadom-Boakye kuratiert. Einige ihrer Ausstellungen wurden in Institutionen auf der ganzen Welt gezeigt und mit Preisen wie dem AICA Award for Best Exhibition und dem South Bank Sky Arts Award für visuelle Kunst ausgezeichnet.

Gad saß einer Reihe von Jurys bei, unter anderem für den Oskár Čepan Award 2022 und 2023, den OGR Award 2023, den Prix de Rome 2019 und 2021 in der Kategorie Bildende Kunst und den Ammodo Tiger Short Award 2021 des Internationalen Filmfestivals Rotterdam. Sie trägt regelmäßig zu Kunstkatalogen bei und hat mehrere Bücher über zeitgenössische Kunst herausgegeben. Zudem war sie Redakteurin für Ibraaz (ibraaz.org), einer Online-Plattform, die sich von 2012 bis 2017 der visuellen Kultur im Nahen Osten und Nordafrika widmete. Sie sitzt im Vorstand von Rib Art Space, einem Projektraum in Rotterdam, und im Programmausschuss der Zeitschrift Extra Extra.

Julia Greenway

Julia Greenway ist Kuratorin in London und beschäftigt sich mit dem Einfluss digitaler Medien auf die ästhetische Darstellung von Geschlecht, Wirtschaft und Umwelt. Als Kuratorin an der Londoner Zabludowicz Collection arbeitete sie mit an der Einzelausstellung der Künstlerin LuYang und der thematischen Gruppenausstellung Among the Machines. Nachdem sie 2018 nach London kam, realisierte sie dort bei Cubitt Artists Gery Georgievas UWU Channel Radiance sowie Joey Holders ortsspezifische Installation Semelparous in einem ehemaligen Fitnessstudio. Zuvor war sie von 2017 bis 2018 Curator in Residence bei Oregon Contemporary in Portland, Oregon, und seit 2015 kuratorische Leiterin von Interstitial, einer Galerie für neue Medien in Seattle, Washington. Greenway hat einen MFA in Kuratieren vom Goldsmiths College, University of London, und einen BFA in Malerei von der Grand Valley State University, Michigan.

Sabine Himmelsbach

Sabine Himmelsbach ist seit 2012 Direktorin des HEK (Haus der Elektronischen Künste) in Basel. Nach einem Kunstgeschichtsstudium in München arbeitete sie von 1993 bis 1996 für Galerien in München und Wien und wurde anschließend Projektleiterin für Ausstellungen und begleitende Symposien beim Steirischen Herbst in Graz. 1999 übernahm sie die Ausstellungsleitung am ZKM | Zentrum für Kunst und Medien in Karlsruhe. Von 2005 bis 2011 leitete sie das Edith-Russ-Haus für Medienkunst in Oldenburg. 2011 kuratierte sie gateways. Kunst und vernetzte Kultur für das Kumu Kunstmuseum in Tallinn, Estland, im Rahmen der Europäischen Kulturhauptstadt Tallinn 2011. Zu ihren Ausstellungsprojekten am HEK gehören Ryoji Ikeda (2014), Poetics and Politics of Data (2015), Rafael Lozano-Hemmer: Preabsence (2016), unREAL (2017), Lynn Hershman Leeson: Anti-Bodies,

Eco-Visionaries (2018), Entangled Realities. Leben mit künstlicher Intelligenz (2019), Making FASHION Sense und Real Feelings. Emotionen und Technologie (2020). 2022 realisierte sie die Ausstellung Earthbound – Im Dialog mit der Natur für die Europäische Kulturhauptstadt Esch-sur-Alzette in Luxemburg. Zu ihren jüngsten Ausstellungsprojekten gehören Collective Worldbuilding – Kunst im Metaversum und Exploring the Decentralized Web – Kunst auf der Blockchain (beide 2023). Als Autorin und Dozentin widmet sie sich Themen rund um Medienkunst und digitale Kultur.

Ariane Koek

Ariane Koek ist eine international anerkannte Expertin, Produzentin, Kuratorin und Autorin in den Bereichen Kunst, Wissenschaft, Technologie und Ökologie, mit einem besonderen Interesse an den neuen Grenzen der Physik. 2009 initiierte sie das Programm Arts at CERN und konzipierte und leitete es einschließlich der Collide-Residenzen bis 2015. Seitdem arbeitet sie für internationale Stiftungen, Philanthrop*innen, Museen, Universitäten und Regierungseinrichtungen auf der ganzen Welt, unter anderem die Europäische Kommission, die Wellcome Collection, das Exploratorium USA, den Stiftungsfonds des Internationalen Komitees vom Roten Kreuz, die Schweizer Kulturstiftung Pro Helvetia, die Science Gallery International und das Cavendish-Laboratorium der Universität Cambridge. 2022 wurde sie mit einem Bogliasco-Stipendium ausgezeichnet und 2021 als Kreativdirektorin des offiziellen italienischen virtuellen Pavillons der Architekturbiennale in Venedig eingeladen. Sie ist Mitglied in den Kulturausschüssen des HeK (Haus der Elektronischen Künste) in Basel, Schweiz; des Edgelands Institute (Harvard University/Genf); der Kunstorganisation AND (Abandon Normal Devices) in Manchester, UK, und der Gemeinsamen Forschungsstelle der Europäischen Kommission in Ispra, Italien, die sich der wissenschaftlichen Umweltforschung und der politischen Entscheidungsfindung in Europa widmet. Zudem ist sie Clore Fellow, Salzburg Global Fellow und Fellow of the Royal Society of Arts (FRSA). Zu ihren Veröffentlichungen gehört Entangle: Physics and the Artistic Imagination (Hatje Cantz).

Paul Luckraft

Paul Luckraft arbeitet in London als Kurator und Autor, insbesondere zu den Auswirkungen moderner Technologien auf Kunst, Gesellschaft und das Selbst. Als leitender Kurator der Zabludowicz Collection präsentierte er bis Februar 2023 große Einzelausstellungen von Künstlerinnen wie LuYang, Shana Moulton und Rachel Maclean, die jeweils neu in Auftrag gegebene Werke zeigten. Er kuratierte auch thematische Gruppenausstellungen, darunter Among the Machines, You Are Looking at Something That Never Occurred und Emotional Supply Chains. Darüber hinaus war er federführend an der Entwicklung des Programms Zabludowicz Collecti-on Invites beteiligt, das aufstrebende Künstler*innen im Vereinigten Königreich mit Einzelpräsentationen unterstützt, und kuratierte über 35 solcher Ausstellungen. Neben der Organisation von Ausstellungen hat er zahlreiche Publikationen herausgegeben und Texte verfasst. Zuvor war er Kurator bei Modern Art Oxford und Assistenzkurator bei FACT, Liverpool. 2006 war er einer der Mitbegründer des Royal Standard in Liverpool, eines von Künstler*innen betriebenen Atelier- und Projektraums. Er hat einen MA in Kunstgeschichte von der Open University und einen BA in Bildender Kunst von der Liverpool John Moores University.

House of Electronic Arts

To the artist / An die Künstlerin.
To the authors / An die Autorinnen und Autoren.
To all who had part in building the project / An alle, die zum Erfolg des Projekts beigetragen haben.

To the financial supporters of HEK / An die Subventionsgeber des HEK

cms
Christoph Merian Stiftung

KULTURELLES.BL
BILDUNGS-, KULTUR- UND SPORTDIREKTION

Kanton Basel-Stadt
Kultur

Schweizerische Eidgenossenschaft
Confédération suisse
Confederazione Svizzera
Confederaziun svizra

Swiss Confederation

Federal Department of Home Affairs FDHA
Federal Office of Culture FOC

Exhibition at HEK and publication are supported by / Die Ausstellung am HEK und die Publikation werden unterstützt von

K B H.G

Kulturstiftung Basel H. Geiger

Publication accompanying the exhibition / Diese Publikation erscheint anlässlich der Ausstellung

Libby Heaney: Quantum Soup / Quantensuppe

An exhibition by HEK (House of Electronic Arts) / Eine Ausstellung des HEK (Haus der Elektronischen Künste)

March 23 – May 26, 2024 / 23. März – 26. Mai 2024

Published by / Erschienen im Hatje Cantz Verlag GmbH
Mommsenstrasse 27
10629 Berlin
Germany
www.hatjecantz.com

A Ganske Publishing Group Company / Ein Unternehmen der Ganske Verlagsgruppe

© 2024 Hatje Cantz Verlag, Berlin
© 2024 Texts / Texte: Authors / Autorinnen und Autoren
© 2024 Illustrations / Abbildungen: The artists and their legal successors; Photographers according to the image credits. / Die Künstler*innen oder ihre Rechtsnachfolger*innen. Fotograf*innen entsprechend dem Bildnachweis.

Editor / Herausgeberin: Sabine Himmelsbach for / für HEK (House of Electronic Arts / Haus der Elektronischen Künste)

Contributions by / Beiträge von: Amira Gad, Julia Greenway, Sabine Himmelsbach, Ariane Koek, Paul Luckraft

Proofreading / Korrektorat: Toby Axelrod (English / Englisch), Sabine Wolf (German / Deutsch)

Translation / Übersetzung: Kate Whitebread (English – German /Englisch – Deutsch), Anna Stühler (German – English / Deutsch – Englisch)

Graphic design / Gestaltung: Hauser Schwarz, Basel

Project management / Projektmanagement: Angelika Thill, Hatje Cantz

Printed, binding, and reproductions / Druck, Buchbinderei, Litho: DZA Druckerei zu Altenburg GmbH, Altenburg

Typeface / Schrift: GT Planar

Paper / Papier: Fedrigoni Arena Rough Extra White 120 gm², Magno Gloss 135 gm²

ISBN 978-3-7757-5770-6

Printed in Germany

Image credits / Bildnachweis:
Tim Bowditch: p./S. 25, 124, 125, 126, 127;
Libby Heaney: p./S. 12, 13, 14, 15, 16, 20, 21, 22, 23, 25, 28, 31, 34, 38, 40, 44, 62, 67, 74, 76–77, 78, 79, 80–81, 82–83, 86–87, 90–91, 92–93, 96–97, 102–103, 104, 105, 106–107, 108–109, 112–113, 116, 117, 120, 120–121, 130–131, 132–133, 134, 135, 136;
Sam McCormick (Entangled Others): p./S. 49, 56;
Tom Ross (Refik Anadol): p./S. 49, 56;
Franz Wamhof: p./S. 10, 14, 15, 16, 18, 22, 23, 24, 25, 73, 75, 84–85, 88–89, 94–95, 98–99, 100–101, 110–111, 114–115, 118–119, 122–123, 128–129.

Cover illustration / Umschlagabbildung: Libby Heaney, *Heartbreak and Magic*, 2024